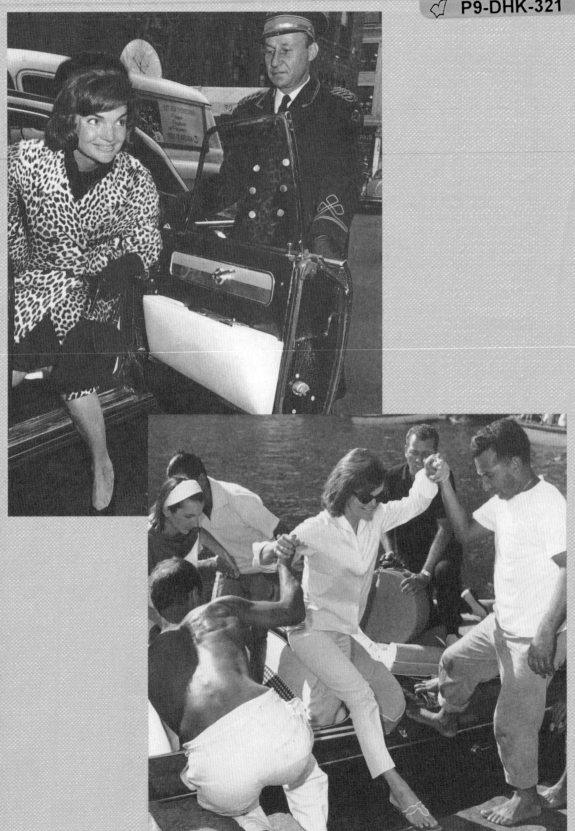

JACKIE

The Clothes of Camelot

Also by Jay Mulvaney

Kennedy Weddings: A Family Album

JACKIE

The Clothes of Camelot

JAY MULVANEY

With a Foreword by

DOMINICK DUNNE

St. Martin's Press ❧ New York

To Tommy Lynch

A friend may well be reckoned
the masterpiece of Nature.
—Emerson

www.stmartins.com

Foreword copyright © by Dominick Dunne. All rights reserved. Originally appeared in *Vanity Fair*.

Library of Congress Cataloging-in-Publication Data

Mulvaney, Jay.
 Jackie : the clothes of Camelot/ Jay Mulvaney.—1st U.S. ed.
 p. cm.
 ISBN 0-312-28197-8
 1. Onassis, Jaqueline Kennedy, 1929—Clothing. 2. Onassis, Jaqueline Kennedy, 1929—Pictorial works. 3. Celebrities—United States—Pictorial works. 4. Presidents' spouses—United States—Pictorial works. 5. Fashion—United States—History—20th century. I. Title.

CT275.0552 .M85 2001
973.922'092—dc21
[B]
 2001018565

First Edition: May 2001

10 9 8 7 6 5 4 3 2 1

Contents

Acknowledgments

Thanks first to my friend Bill Bonecutter. A short conversation on an August afternoon sparked the idea for this book. He is a good friend and a good man.

Jim Hill and Alan Goodrich from the John F. Kennedy Library were of invaluable help. Their knowledge of the collections housed under their care is as complete as their patience is indefatigable. *This is absolutely the last thing I'll ask for* seems to be my continuing mantra with them. Thanks also to Barbara Quigley and Catja Burkhardt in the library's AV department.

Thanks to Oleg Cassini for sharing some memories of his magical partnership with Jacqueline Kennedy and for putting those times into perspective, and to Jim Wagner of the JFK Library for sharing his knowledge and expertise.

Ron Brenne and Norman Currie from Corbis/Bettmann, Jorge Jaramillo from AP/Worldwide, and especially John Cronin from the *Boston Herald* were all gracious and helpful, especially so since I was working under an intense deadline. Special thanks to my fellow Vassar alumna Lori O'Leary of the Franklin Mint for coming through in a pinch.

Heartfelt thanks to Dick Duane and Bob Thixton, who make everything work so smoothly; to Jim Spada for his advocacy; to Dominick Dunne for his generosity; to Sally Kilbridge for her early help; to Caroline Gervase and Kathrin Seitz for their unconditional support; and to Paula and Bob Cashin for their hospitality and love.

At St. Martin's, my thanks begin with my editor, Charles Spicer, and his team, Dorsey Mills, Joe Cleeman, and Anderson Bailey, and include Amelie Littell, Karen Gillis, Susan Joseph, Henry Sene Yee, Patty Rosati, and especially Meg Drislane for her patience and quick humor, James Sinclair for his elegant design and for treking to the Garment District for that swatch of pink douppioni silk, and Sally Richardson.

And lastly, special thanks to my favorite people in the world: Meghan Cashin, Colleen Cashin, and Kevin Cashin.

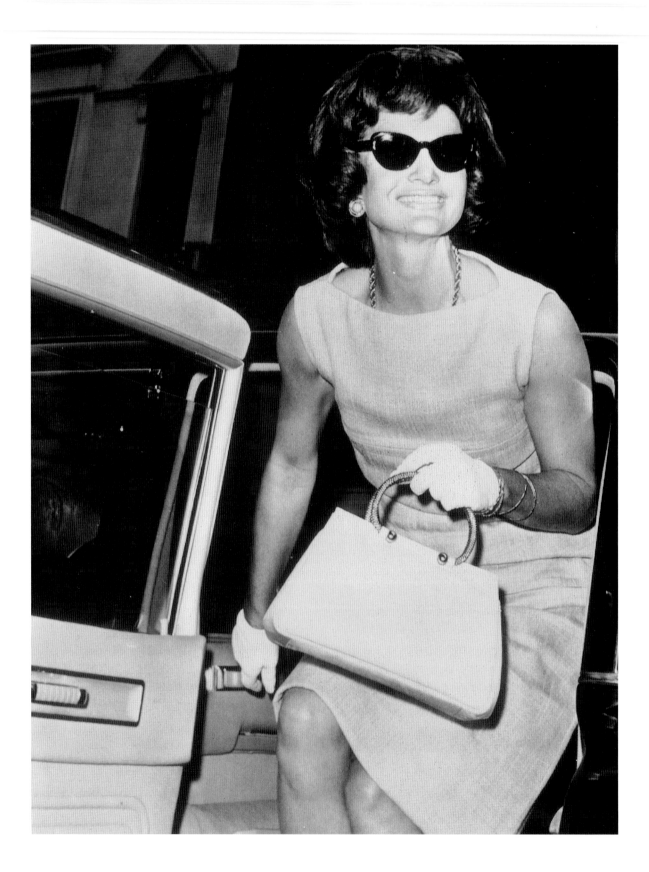

Foreword by Dominick Dunne

The public easily tires of icons, but America's fascination with Jacqueline Bouvier Kennedy Onassis never burned out; it remained as constant as the eternal flame she designated for her husband's grave. Her fame was free of the resentment that fame sometimes produces, because she didn't work at it, and she never grabbed for the perks that accompany it. No publicists plotted her course. No perfume company paid for her name to advertise its product. She was simply who she was, part of the fabric of American culture. In grand circles, the word *class* is considered a bad-taste word, but *class* is really the key word to describe her. Style, chic, and other such attributes are acquirable; class is not. Either you have it or you don't. Jackie had it in spades.

If she enjoyed privilege, her privilege was never resented because she earned it with her courage. In New York she could be seen doing the things that all New Yorkers do— hailing cabs, going to work, walking in Central Park, taking in a movie in her neighborhood. Apart from the pesky paparazzi, people did not intrude on her privacy, except maybe to call out, "Hi, Jackie," when they passed her, and some of them received a smile back, or a wave, as she kept on walking her fast walk, in the celebrity manner of seeing but not seeing called blindsight.

She belonged to us for more than thirty years. We watched her react and then act with magnificence at the most horrible moment in her life, and we would never forget it. With the instinctive knowledge of the great, knowing when their moment is at hand, she in effect picked up the flag dropped by her fallen husband. She was far too young for the life of perpetual widowhood and sainthood that the public demanded of her. She went through a period of disfavor when she married Aristotle Onassis, whose penchant for gross extravagance and unfortunate public behavior sullied and stained her goddesslike stature for the few years they were together.

Following her second widowhood, she did not retreat into the social life of New York that was so available to her and that so longed for her presence. On the rare occasions— several times a year—when she appeared at social functions, she always caused a hush when she entered a room. Even the most sophisticated people turned and stared at her; no one was ever so used to her that her arrival or departure went unnoticed. She stood for the

requisite moment of picture taking, always understanding the exigencies of fame. She moved in; the crowd gave way to her. She was what royals used to be but so seldom are any longer. People never rushed up to talk to her. She would recognize a face and speak to that person. In conversation, her eyes rarely wandered from the eyes of the person to whom she was speaking.

Although Jackie conformed to the principles of her husband's extraordinary family, she was never assimilated into it as one of them. She held herself separate, refusing to lose her identity. Her Bouvier roots and Auchincloss ties remained very much a part of her. In the annals of society, it was Jack, not Jackie, who had married up. The close friends of her life were not from society, however, but from the arts.

The only time I ever actually had a conversation with her was at a lunch party at Mortimer's to celebrate the publication of a book she had edited about Fred Astaire, a compilation of pictures and quotes about the great star from friends and coworkers whom my friend Sarah Giles had interviewed. I had always longed to meet her, but when the moment came, I couldn't think of a single thing to say. "Oh, God, don't let me go mute," I prayed. The slight smile on her face indicated that she knew that people sometimes had that feeling in her presence. Of course, she saved the day. She mentioned a quote of mine in the book and asked me something about Fred Astaire, whom I had known because his daughter was a friend of mine, and suddenly I was off and running. Only later did I realize that I had done all the talking. She had just given me the subject.

That was her way. She gave only a handful of interviews; stayed focused on her goals, not the ones we, fueled by fan magazines and a pervasive celebrity culture, imagined for her; and gave us few clues about who she was. And so, in a very real way, it is through her clothes, of all things, that we came to know her best. They are a shortcut, a visual clue to her persona and personality. In *Jackie: The Clothes of Camelot,* we are treated to a pictorial history of a woman who was, in a sense, the last of the great silent-movie stars.

Introduction

I have but one Queen, and her name is Jacqueline Kennedy Onassis.

—Tina Turner, 1985

Forty years ago, Jacqueline Kennedy entered the public consciousness and instantly became the classic American fashion icon—a role she played throughout her lifetime. For thousands of women, from Tina Turner (growing up as Anna Mae Bullock in Nutbush, Tennessee) to Diana, Princess of Wales, the preeminent role model for a woman in public life was Jackie.

When, in an application to *Vogue*'s Prix de Paris competition in 1951, the young Jacqueline Bouvier confessed her wish to "be a sort of Overall Art Director of the Twentieth Century," little did she realize that her sensibility would dominate the world of fashion for the second half of that very century. In January 1961 she introduced a look that was crisp, clean, simple, and young. She revolutionized American fashion, bringing American designers to the forefront of the world's stage and breaking the stranglehold of European, especially French, haute couture. Overnight, thanks to Jackie and those A-line dresses and pillbox hats, American women didn't have to look overseas to find fashions that were elegant and chic.

She was, of course, about more than just the *clothes*. The list of Jacqueline Kennedy's tangible contributions is both real and substantial, from restoring the White House interior and saving Lafayette Square's row houses to her efforts to enlarge our cultural landscape, from her driving support of the National Cultural (now Kennedy) Center and of

government support of the arts, which led, ultimately, to the creation of the National Endowment for the Arts.

Then there is her intangible legacy, which has a kind of romantic evanescence: that sublime sense of self that captivated first us, and then the world; the incredible strength of character; the majesty with which she presided over the White House; the public displays of courage and dignity during that terrible weekend in November.

She was supremely confident about the way she presented herself to the public, and the imagination and style with which she did it were obvious in the way she dressed: the crispness of that silhouette, the sophisticated color palette—Venetian yellow, Watteau rose, Nattier blue, and Tintoretto gold—all those glorious fabrics, with luxurious names like peau d'ange, a silk so fine it was called "the skin of an angel," silk georgette, peau de soie, Swiss double satin, and silk triple chiffon (somehow single just wouldn't do).

So many of her clothes stay in our collective aesthetic memory. There's the inaugural ensemble, the pale fawn-colored coat with the sable collar, and the big round pillbox hat. The Givenchy evening gown she wore in Paris, its satin bodice embroidered with red and blue flowers in sartorial tribute to her host country. That dark wool suit worn for the televised tour of the White House. The sleeveless A-line dresses that she wore to church, her head covered with a lace mantilla. The hot-pink maternity shift worn during the summer of 1963. And that other pink ensemble, that Chanel suit that has been engraved on our national psyche for almost forty years. A glimpse of the color, the nub of the fabric, and the box cut of the jacket instantaneously reminds us of one of the defining events of twentieth-century American history.

From young women coming of age in the 1960s to legendary world leaders like de Gaulle and Khrushchev, from punk-rock musicians (Human Sexual Response and their "I want to be Jackie Onassis, oh yeah" anthem) to contemporary designers like Vera Wang and Michael Kors, Jacqueline Kennedy Onassis holds fast as a symbol of American glory, American glamour, and American style.

Her style endures to this day. Each season, fashion brings us a variation on the "Jackie look"—spare, elegant, with antecedents in early Givenchy and Balenciaga—yet always a fresh, young, *American* look.

What a delicious irony for a woman who once said, "I have no desire to influence fashions. That is at the bottom of any list."

Placing our fascination with Jackie Kennedy in historical perspective, then, graces it with the aura of legitimacy. Pulitzer Prize–winning historian Doris Kearns Goodwin once observed of Jackie: "Culturally something happened between her and the decade that she lived in and that is what is really interesting to try and figure out." And try to figure it out we continue to do.

It's also encouraging to know that our fascination with her, and her wardrobe, comes with a Presidential endorsement, as evidenced in this charming anecdote told by a Vassar classmate of Jackie's. During a visit made to the White House in 1961, "Jack Kennedy

came up from the Oval Office because he liked to see what she was wearing. And he said, 'But you've taken your hat off, go get your hat and put it on.' So she did and she put on her little pillbox hat and he was delighted."

Forty years later, so are we.

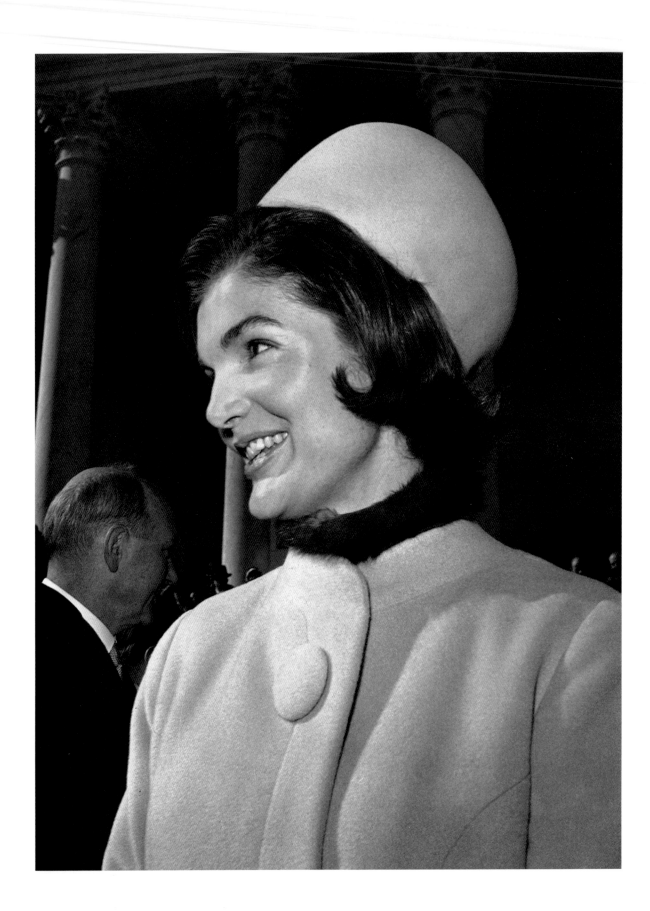

The Inauguration Ensembles

Jackie Kennedy put a little style into the White House . . . and suddenly "good taste" became good taste. I had a small part to do with this. I occasionally gave Jackie advice about clothes. I did suggest that she carry a sable muff on Inauguration Day. It was only for practical reasons—I thought she was going to freeze to death. But I also think muffs are romantic because they have to do with history.

—Diana Vreeland

The birth of an icon in three magical ensembles: two evening gowns and a simple cloth coat that changed American fashion. When Jacqueline Kennedy emerged from her Federal townhouse on the evening of January 19, 1961, in a glorious white satin gown—simple, regal, offset only by her "camellia beauty"—it was the first step on a thousand-day fashion journey that held the world in its thrall.

In the creation of her wardrobe for the White House, Jacqueline Kennedy approached the task with a serious discipline—it was a public image that she would forge, an image that would be the distaff counterpoint to the words and actions of her husband. She would strive to enhance and elevate the tastes and aspirations of a country, and as she said once in reference to the entertainment she offered at the White House, "As long as it's the best, that's what matters." To achieve this best, she entered a collaboration with her sister, Lee Radziwell, the great fashion editor Diana Vreeland, and designer Oleg Cassini.

Jackie took her rich sense of history and style and worked with Cassini to create a look that would revolutionize not just the First Lady but the "fashionable lady" of the early 1960s. Cassini, a Russian aristocrat who designed costumes for Hollywood films in the 1940s and '50s, realized that this collaboration was akin to a theatrical event, set on the largest stage in the world. He recalls that "Jackie reminded me of an ancient Egyptian princess, very geometric, even hieroglyphic, with the sphinxlike quality of her eyes, her long neck, slim torso, broad shoulders, narrow hips, and regal bearing. . . . I wanted to dress her cleanly, architecturally, in style. I would use the most sumptuous fabrics in the purest interpretations. I called it the 'A-line.'" He was a friend of both her husband and her father-in-law, a man whom she could trust to be discreet in many areas, not the least of which was protecting the enormous costs of building a world-class wardrobe from becoming a political liability. Joe Kennedy was keenly aware of this, advising Cassini not to "bother them at all about the money, just send me an account at the end of the year. I'll take care of it." In this unique collaboration, Cassini was a vehicle for a very calculated impression of an individual sensibility.

Wearing a black-and-white glen plaid wool suit and a red suede beret, and accompanied by her press secretary, Pamela Turnure, Jackie waves to well-wishers as she prepares to board the family's private plane, the *Caroline*, to fly to Washington for the inaugural festivities.

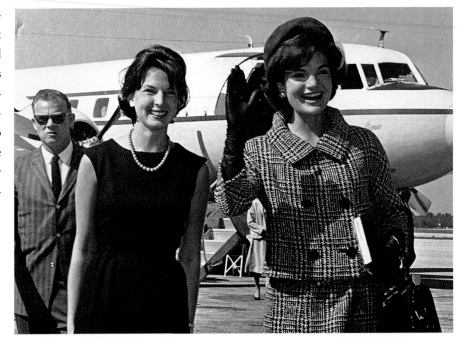

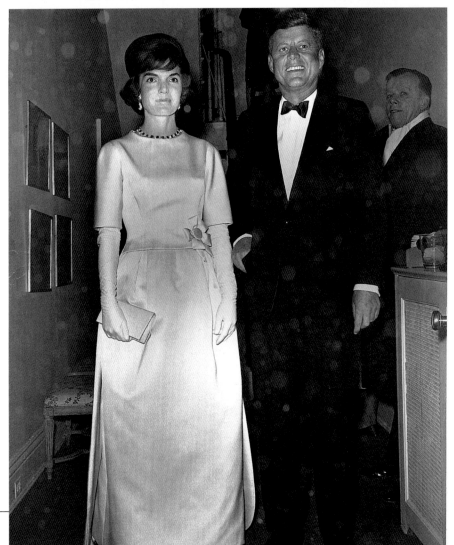

With Jackie casting an apprehensive glance toward the falling snow, the glamorous couple, with pal Bill Walton in tow, prepares to leave for the Inaugural Gala. Her Oleg Cassini gown, of sumptuous white Swiss double satin, appealed to Jackie's sense of elegant simplicity.

"The first sketch was of a simple white satin full-length evening dress. . . . The lines were unusually modest . . . but the quantity of the fabric and the luxury of the satin made it regal, and altogether memorable. I watched her carefully for a reaction and it was immediate, visceral. 'Absolutely right!' she said."

—Oleg Cassini

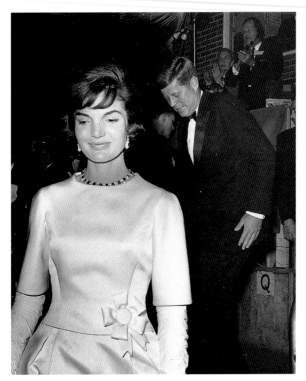

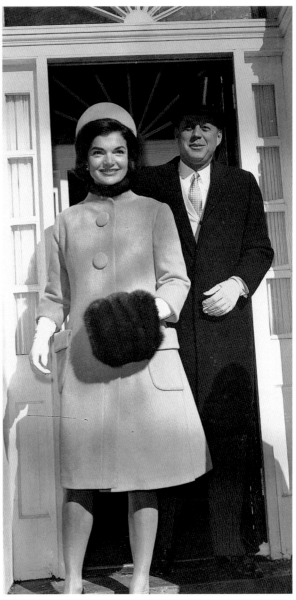

Jackie had arranged, through her social secretary, Letitia Baldrige, to borrow the emerald-and-diamond necklace from Tiffany's, Tish's former employer. She warned Tish, though, that "if it gets in the newspapers, I won't do any more business with Tiffany's. If it doesn't, we'll buy all state presents there."

Mr. and Mrs. John F. Kennedy leave their Georgetown home for the last time. Of her costume—a fawn-colored wool coat with a sable ring collar and matching sable muff, and that famous pillbox hat—Jackie said at the time, "I just didn't want to wear a fur coat. I don't know why, but perhaps because women huddling on the bleachers always looked like rows of fur-bearing animals."

Oleg Cassini showed fashion editors a sketch of the inaugural ensembles just after the announcement of his selection as official couturier in January 1961. Recalling those days forty years later, he said, "I dressed her very young. . . . It was a metamorphosis of Jackie, from playing one role on to another one on a grander scale."

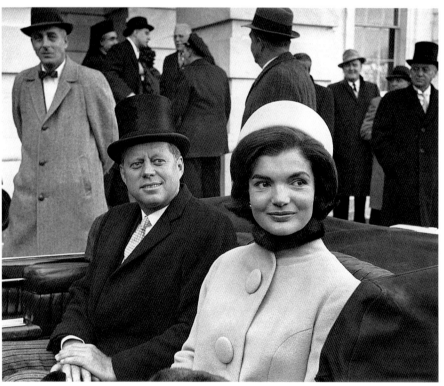

"I know we are all older and wiser now; but do you remember how exciting it all seemed then? Do you remember how young they were, how *fresh* they looked, and how proud we were of them?"
—Oleg Cassini

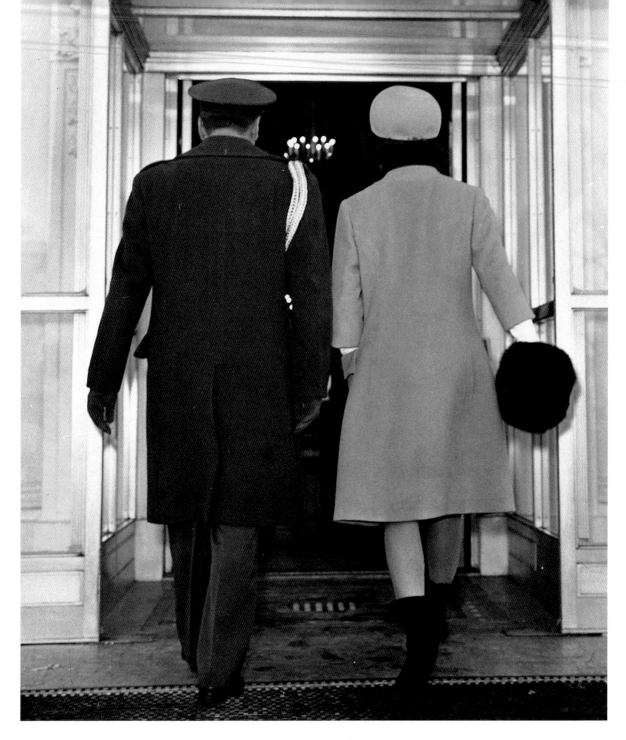

Jacqueline Kennedy enters the White House for the first time as First Lady. Numbed by the freezing temperature, still unwell from the birth by cesarean section of her son two months earlier, and facing the daunting prospect of five inaugural balls that evening, Jackie retired to the Queen's Bedroom for some much-needed rest. She missed the first social event, a reception for her and the President's families, in the home that she would preside over for the next thirty-four months.

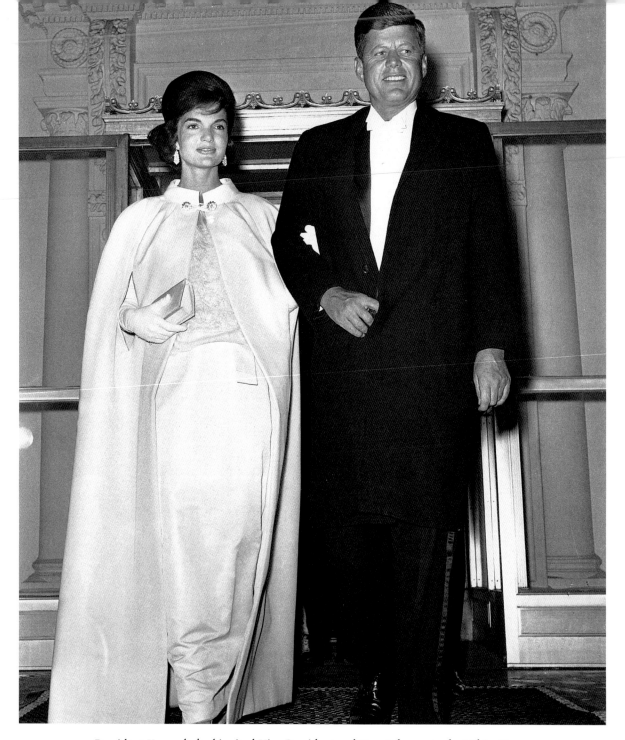

President Kennedy had invited Vice President and Mrs. Johnson to the White House before setting out for the inaugural balls. They were in the Red Room when Jackie floated in, wearing a gown of her own design. "Darling," JFK said to his wife, "I've never seen you look so lovely. Your dress is beautiful." Turning to an usher, he proclaimed, "Bring some wine." A bottle of iced Dom Pérignon was immediately produced, and the new President toasted the radiant First Lady.

This description of the inaugural-ball costume was released to the press:

The dress is a full-length sheath of white silk peau d'ange veiled with white silk chiffon. The hip-length bodice is richly embroidered in silver and brilliants. It is covered by a transparent overblouse of white silk chiffon. The back of the bodice is similar to the front.

The floor-length cape is made of the same white silk peau d'ange and completely veiled in silk triple chiffon. Under the ring collar, the cape is fastened with twin embroidered buttons. The shape of the cape is an arch from shoulder to hem with soft waves in back. It is also lined with white silk peau d'ange and has two arm slits.

With the ensemble Mrs. Kennedy will wear 20 button white glacé kid gloves and carry a matching white silk peau d'ange tailored clutch purse. Mrs. Kennedy's shoes will be matching white silk opera pumps with medium high heels.

Jackie looks faintly bemused at JFK's expression (perhaps he'd learned that the inaugural-ball gown cost three thousand dollars). Later in the evening he said to the throngs at one of the parties, "I don't know a better way to spend an evening—you looking at us and we looking back at you."

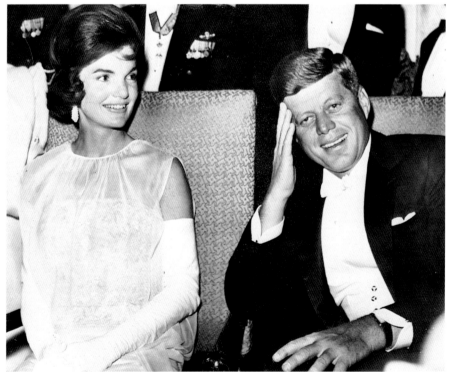

The inaugural gown was indeed Jacqueline's own design, created for her by the custom shop at Bergdorf Goodman in New York. It precipitated a minor crisis within the fashion world, however, as, prior to Cassini's appointment, Jackie had commissioned Bergdorf's for the gown to wear at the inaugural balls and Ben Zuckerman for a coat for the swearing-in ceremony. She compromised, writing to Cassini that, to her relief, "all the furor is over—and done without breaking my word to you or Bergdorf's. Now I know how poor Jack feels when he has told 3 people they can be Secy. of State." Bergdorf's got the inaugural gown—"One dress," Oleg sniffed to the press— and Cassini the coat and dress worn for the inauguration.

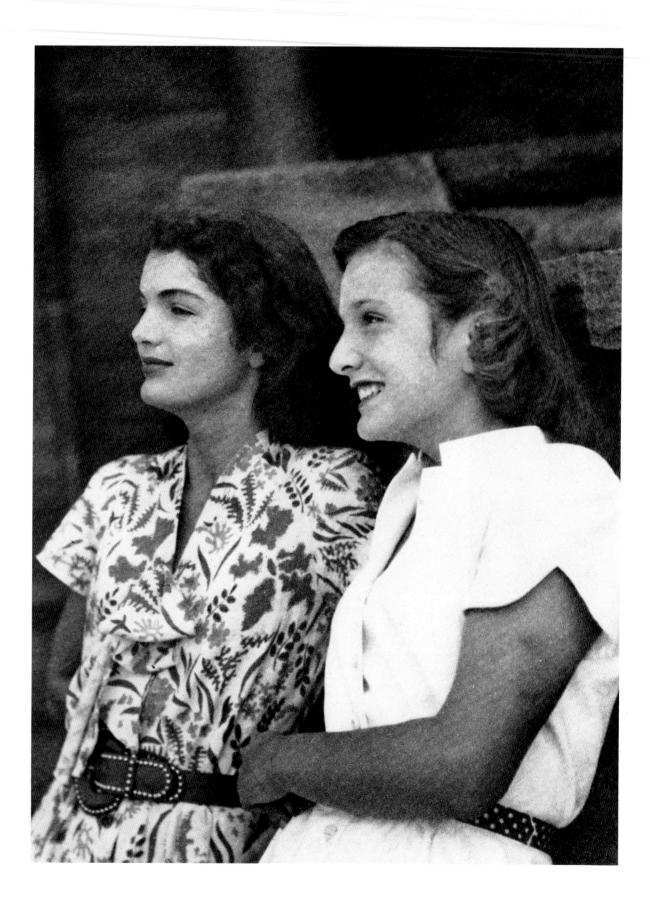

Early Fashion Influences

Jackie came dashing in, laden with dresses, fashion magazines, and a sketch pad. She was as gracious as her mother, as she explained that the ready-made dresses needed some alterations in the waistline and the bustline. After showing the dresses to me, she brought out her own sketches—if they could be called sketches. "Squiggles" would be more appropriate. "Mother recommended you highly, Mrs. Rhea, and said you'd be able to understand what I want." Jackie said with a warm little smile.

—Mini Rhea,
I Was Jacqueline Kennedy's Dressmaker

In 1950 Jacqueline Bouvier sketched this amusingly candid self-portrait:

As to physical appearance, I am tall, 5'7", with brown hair, a square face and eyes so unfortunately wide apart that it takes three weeks to have a pair of glasses made with a bridge wide enough to fit over my nose. I do not have a sensational figure but can look slim if I pick the right clothes. I flatter myself on being able at times to walk out of the house looking like the poor man's Paris copy, but my mother will run up to inform me that my left stocking seam is crooked or the right-hand top coat button is about to fall off. This, I realize, is the unforgivable sin.

Jackie's mother, Janet Auchincloss, had encouraged her to enter *Vogue*'s Prix de Paris contest in 1951. She won, impressing the editors with her flair and originality, choosing playwright Oscar Wilde, ballet impresario Serge Diaghilev, and poet Charles Baudelaire as the three men she would most like to meet. She won the contest but turned down the first prize—a yearlong editorship split between New York and Paris. Returning home to Merrywood, her stepfather's estate outside of Washington, Jackie was introduced to her mother's dressmaker, Mini Rhea, who recalled Mrs. Auchincloss telling her, "My daughter would just love you. She likes to design her own clothes and I know she would love to work with someone like you who could help her with them." Jackie did have many ideas about design and fashion, and her collaboration with Mrs. Rhea presaged the work she would do a decade later with Oleg Cassini. Rushing in with fabrics, sketches, and pages pulled from fashion magazines, she and Mrs. Rhea enjoyed a close relationship, so much so that Jackie would stop by the dress shop to change clothes for her dates with the young senator from Massachusetts.

The dressmaker was impressed by the young woman's strong sense of self. "I'm trying to develop a certain clear-cut line," Jackie would tell her, rejecting the prevailing styles and finding inspiration in French fashion magazines. If she liked a particular dress, she would have it made in different fabrics, with only modest changes.

Marriage, and her emergence as the wife of a public figure, enabled Jackie to expand her scope. She became a reliable customer of the Paris couture. One designer, talking about her preferences, said at the time, "She prefers simple things, always a little sporty, and insists on being underdressed. She orders many daytime models [in her] favorite colors—Gauguin pink, followed by black, turquoise, gray, and white. One time she fell in love with a coat and immediately took it to London with the hem just basted."

Greatly attuned to political fallout, Jackie once offered this bit of fashion philosophy: "I don't like to buy a lot of clothes and have my closets full. A suit, a good little black dress with sleeves, and a short evening dress—that's all you need for travel."

Her mother, Janet, once said, "I like to use the word *original* in describing Jacqueline. She was brilliant . . . gifted artistically and always good in her studies. . . . She was very intense and felt strongly about things. She had enormous individuality and sensitivity and a marvelous self-control that perhaps concealed inner tensions. I wouldn't dream of telling Jacqueline what do to. I never have."

Sisters, sisters, there were never such devoted sisters.
Caring, sharing, each and every thing that we are wearing . . .

Lee Radziwell once told Barbara Walters, "And, of course, like most siblings, even though we were particularly close, she found me, I guess, quite annoying, being four years younger. One of the most outstanding things she did to me was to hit me over the head with a croquet mallet so that I was unconscious for about a day, I was told." Exceptionally close for many years, the two daughters of Jack Bouvier and Janet Lee were certainly stylish. Their fashion sense evolved over the years from these identical dresses worn throughout their childhood to strong individual styles that would land both of them in the International Best-Dressed Hall of Fame in the 1960s.

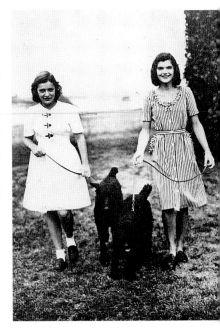

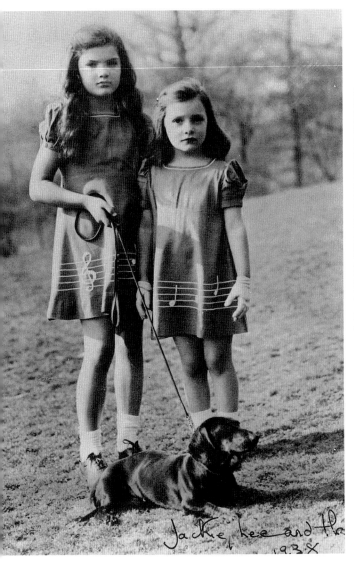

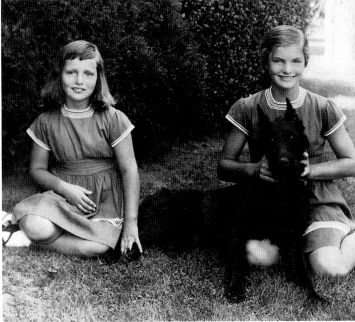

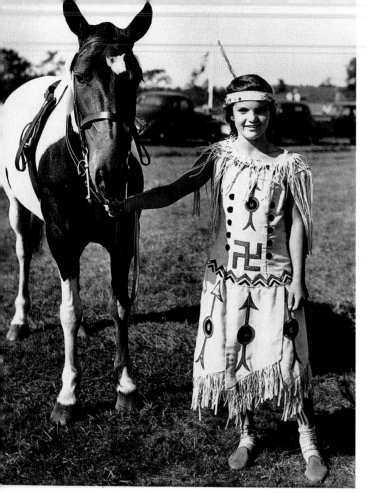

Though it's somewhat jarring today to see nine-year-old Jackie wearing what looks like a swastika on her Indian costume, worn at an equestrian contest in the 1930s, its reversed design is actually an ancient symbol of the sun. Jackie had a lifelong passion for horses and riding, fostered by her mother, a champion rider herself.

Jackie poses at Hammersmith Farm with her mother, sister Lee, and half brother Jamie in 1947. "My mother was very strict, and very old-fashioned, as ladies of her generation were," Lee Radziwell once said. "She would say things to Jackie and me like 'You girls had better learn to play cards or you are going to grow up to be lonely old maids.' She had such classic taste. Her style was either like this [one] dress which she wore every year for Christmas for something like twenty years and was so wonderful, or sports clothes."

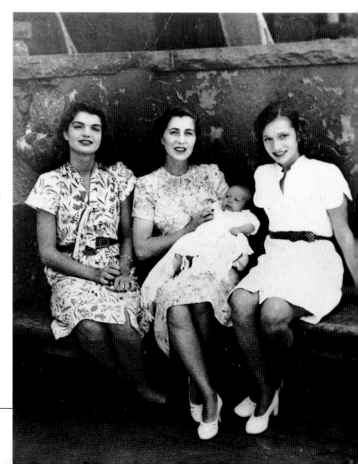

"Being nervous before" is how the debutante Jacqueline inscribed this photograph, taken before a dinner dance that served as a joint coming-out party for her and Newport friend Rose Grosvenor. Jackie's white tulle dress, which came off the rack from a New York department store, cost fifty-nine dollars. Later that year, society columnist Igor Cassini, Oleg's brother and the Liz Smith of his day, bestowed upon Jacqueline Bouvier a dubious honorific: "The Queen Deb of the year for 1947 is Jacqueline Bouvier, a regal brunette who has classic features and the daintiness of Dresden porcelain. She has poise, is soft-spoken and intelligent, everything the leading debutante should be. Her background is strictly 'Old Guard.' . . . Jacqueline is now studying at Vassar. You don't have to read a bunch of press clippings to be aware of her qualities."

The day before sailing for France for her junior-year studies at the Sorbonne, Jackie and her sister students pose with the cultural counselor to the French embassy. Even at twenty, her fashion sense was eye-catching.

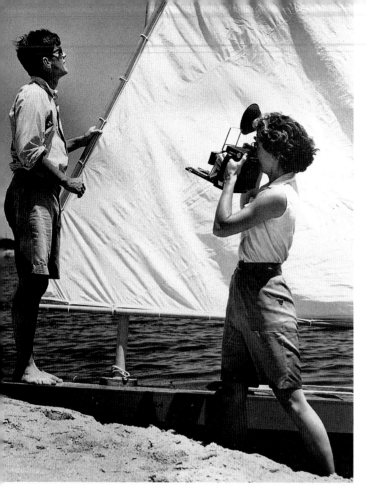

Using her "Inquiring Photographer" bulky camera, Jacqueline Bouvier photographs her fiancé before joining him for a sail on Cape Cod's Lewis Bay. Engaged in June 1953, they were wed in Newport three months later. They are similarly dressed in khaki shorts and white shirts.

The "lampshade" dress—Caroline Kennedy once said that her mother "really didn't like the dress that much. . . . I think she thought it looked a little bit like a lampshade." Jackie was much more vehement to designer Carolina Herrera, telling her, "I had a very bad experience with my wedding. It was the dress that my mother wanted me to wear and I hated it."

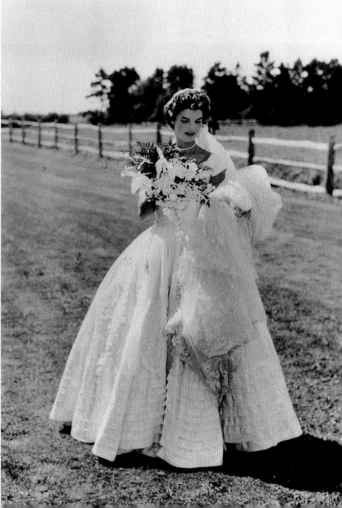

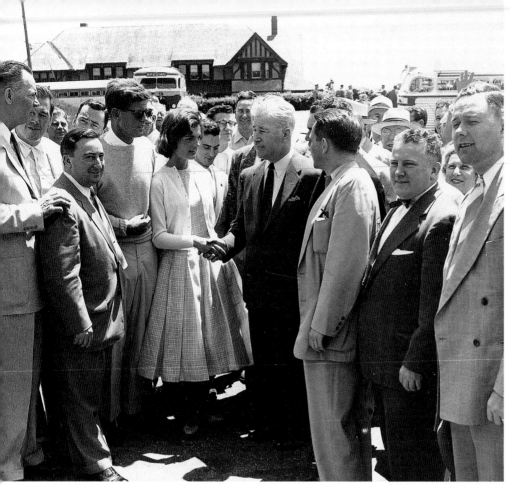

Jackie does Donna Reed in this simple shirtwaist dress and cardigan sweater. She and an equally casual JFK greet supporters near Hyannis Port in 1954, the summer after their wedding.

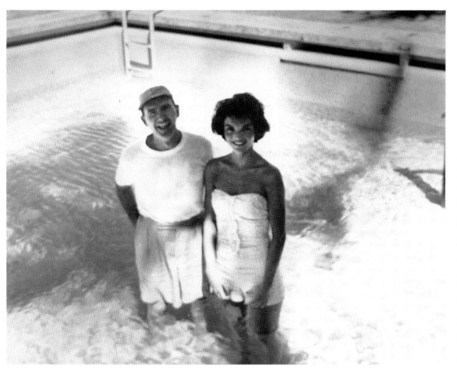

JFK took this snapshot of Jackie and pal Dave Powers in the swimming pool at his father's house in Palm Beach, where he was recuperating from back surgery. To avoid an unsightly tan line, Jackie untied the halter-top bands and wore this modest bathing suit strapless.

In a tailored suit with a prominently featured collar, white kid gloves, and an alligator handbag, Jackie listens attentively as Jack talks with a reporter upon their return to Washington from his recuperation in Palm Beach.

JFK joins his wife and his sister Eunice Kennedy Shriver at the April in Paris Ball at New York's Waldorf-Astoria Hotel. Her strapless satin gown with a simple bow decoration is an early indication of the geometric simplicity found in Oleg Cassini's designs during the White House years. The satin cloak, the glittering evening bag, and the pearls were staples of Jackie's "dressed up" look.

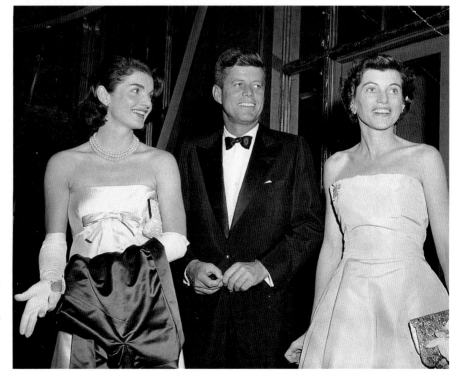

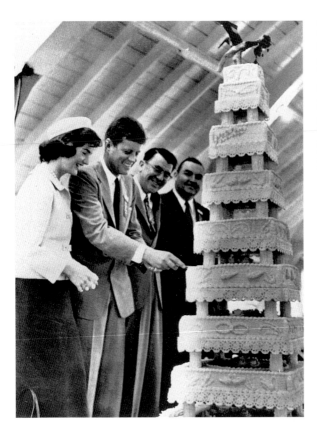

Jackie, wearing a Chanel suit and a pillbox hat, laughs as JFK attempts to cut into a huge cake celebrating his forty-first birthday during a campaign stop in Fall River, Massachusetts.

Actor David Niven recalls dancing with Jackie at New York's El Morocco in 1958: "JFK sat in the back room and when I asked Jackie why he wouldn't join us, she laughed and said, 'He doesn't want to be photographed doing something so frivolous. . . . He wants to be President.'" Her silk tulle gown is adorned with tiny silk flowers, and on her wrist is the diamond bracelet that was a wedding gift from her husband.

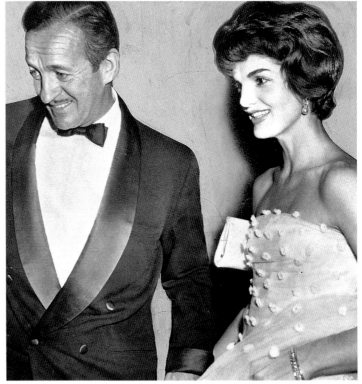

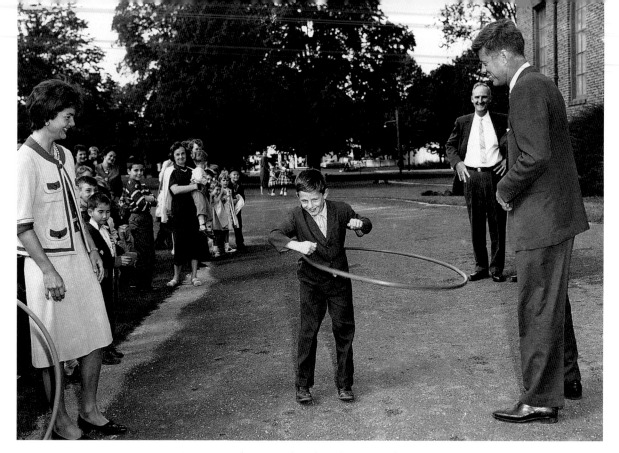

Jackie again chooses Chanel, a longtime favorite, to wear on the campaign trail during JFK's 1958 senatorial reelection bid. Here she watches a young expert demonstrate his skills with a Hula Hoop.

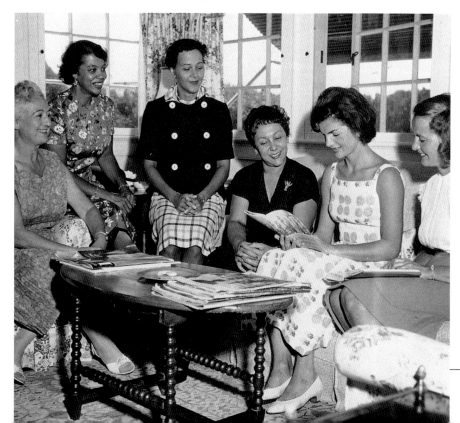

Sitting in the sunroom of her Hyannis Port house, Jackie discusses details of the Ebony Fashion Fair with members of a local women's club. Her cotton dress was a staple of her summer wardrobe.

Two years later, during the Democratic Presidential primaries, on board the family's private plane, the *Caroline*, named for her daughter, Jackie takes a break for some intellectual nourishment, reading Jack Kerouac's *On the Road*.

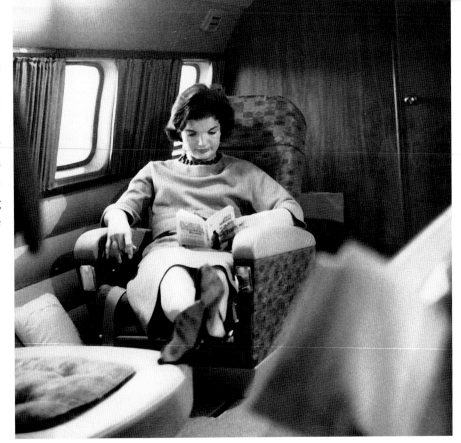

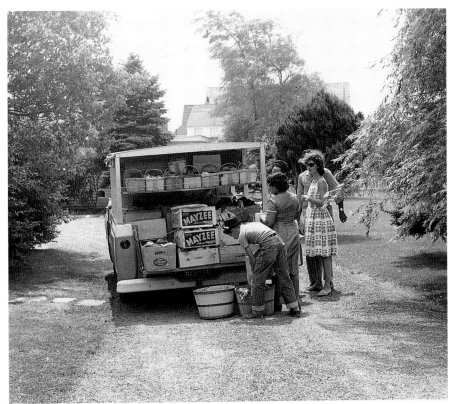

The summer of 1960 gave Jackie the last few weeks of relative anonymity before the rigorous fall campaign. She is seen here buying fruit and vegetables off a farm truck in Hyannis Port. Her simple summer dress does a fairly effective job of masking her almost five-month pregnancy.

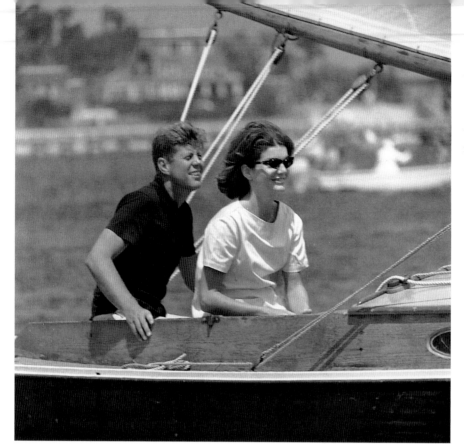

Jack and Jackie sail off the coast of Hyannis Port just after he won the Democratic Presidential nomination.

Noticeably pregnant, Jackie appears at a Democratic rally in New York in September of 1960. Her shopping habits caused a bit of a brouhaha as press reports claimed that she spent up to thirty thousand dollars a year on Paris clothes. She said she was "hurt" and "surprised" at such reports and announced that this maternity dress cost $29.95. When asked directly about the thirty-thousand-dollar figure, she answered famously, "I couldn't spend that much unless I wore sable underwear."

It was the height of luxury, a level of pure couture that few women have ever experienced. Dozens of magnificent evening gowns created specifically for state dinners and gala events. The designs were exquisitely simple and the fabrics extraordinarily luxe, each gown fitted to a quarter inch from an exacting set of measurements (sixty-one inches from the nape of her neck to the floor, seven and three-quarter inches at the shoulder from the center of her back to the armhole). It was dressmaking artistry and a collaboration that charmed the world.

In their early days of working together, Cassini offered Jackie a provocative challenge. "You have an opportunity here," he told her, "for an American Versailles." She had intended to bring a ringing change to the White House, enlisting JFK's support. (He told Letitia Baldrige, "You know, we really ought to have the nicest entertaining here with the greatest distinction.") She planned to make Washington the social and intellectual center of the country. Jacqueline Kennedy saw her husband as a statesman, not a politician. She would bring to him great writers, accomplished artists and thinkers. The food and wine she served would be unrivaled, and the house they presided over would be restored to its early grandeur.

In Cassini she found a willing and able collaborator. He remembers that "her sense of style was very precise; she would make editorial comments on the sketches I sent her. She always knew exactly what she wanted." They took the distillation of her 1950s style, in which she had borrowed liberally from the Audrey Hepburn/Givenchy look, and made it her own—Jackie as naïf, as gamine. When merged with her intellectual sophistication, she became, in the words of one writer, "a woman out of a Cole Porter lyric."

The results were superlative: a series of evening gowns of unparalleled chic and luxury. All followed the dictum that Jackie had set down for "some pretty, long evening dresses suitable for big official dinners. You know the kind I like: a covered-up look. Even though these clothes are for official life, please don't make them too dressy, as I'm sure I can continue to dress the way I like—simple and young clothes, as long as they are covered up for the occasion."

After she had left the White House, *Women's Wear Daily* paid tribute to her: "The Kennedy era in Washington was one of elegance, glamour, and good taste which affected the entire nation and probably the entire world. There is no doubt that Mrs. Jacqueline Kennedy probably did more to uplift taste levels in the United States than any woman in the history of our country. Among the clothes she wore, there are many which certainly can be considered important in fashion, as well as of historical interest [such as] the gowns she wore when the Shah of Iran and other heads of state visited the White House and Mount Vernon."

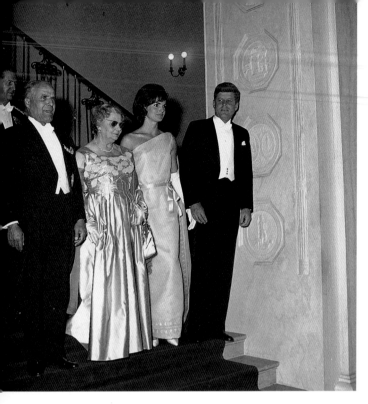

The first state dinner of the Kennedy administration honored President Bourguiba of Tunisia. Oleg Cassini had designed a one-shouldered gown in a soft yellow with a satin bow at the waist and embroidered detail at the hem and on the shoulder drape. Jackie sent the designer to obtain Presidential permission to bare her shoulder. Cassini told JFK, "From the dawn of antiquity, the queen or high priestess has always set the style. That is her role in society, to be a little advanced and thus admired by her people." The President laughed and, shaking his head, caved in. "Okay, Oleg, you win."

Two nights later President Bourguiba and his wife entertained the Kennedys at the Tunisian embassy. Jackie's silk gown was a rarity for her, with its full skirt, uneven hemline, and fussy embroidery at the neck. She quickly returned to her streamlined silhouette.

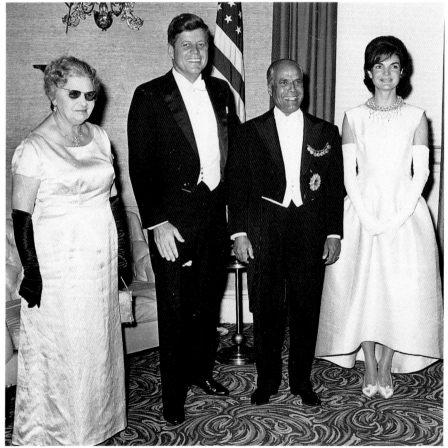

One of the most celebrated of the Kennedy state dinners honored Pakistan's President, Ayub Khan, and was held at George Washington's home, Mount Vernon. Jackie ordered this dress specifically for the evening and location, a full-length columnar sheath of row upon row of narrow lace and organza ruffles. The neckline was her favorite—bateau—straight across the front. Adding a dramatic touch was a chartreuse silk belt that nipped in the waist. The guests arrived at the dinner by sailing down the Potomac, and Jackie wore a matching chartreuse stole to ward off the summer breeze.

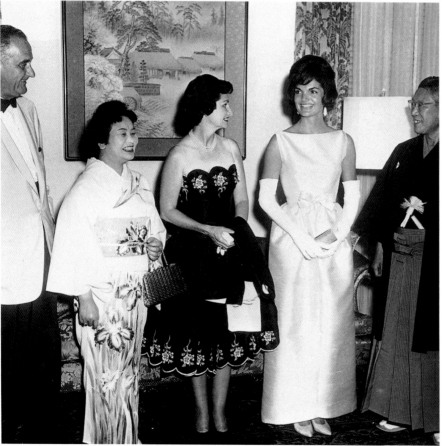

Jackie was sometimes criticized for being a clotheshorse, but she often got double duty out of her clothes. Take this ice blue silk satin dress: it was first worn in London for dinner at Buckingham Palace, then Jackie wore it a few weeks later at a reception at the Japanese embassy in Washington. The President was suffering a cold, so the Vice President and Mrs. Johnson escorted the First Lady. It's fun to see the extreme difference between Jackie's elegant simplicity, Lady Bird's ebullience, and the traditional Japanese kimono worn by the Prime Minister's wife.

Madame Prado, wife of
the Peruvian President,
matches Jackie's elegance
in a simple sheath with
an embroidered bodice.
Jackie's strapless white
gown has a matching short
stole with a simple button
closure. The dress made a
repeat appearance a few
weeks later.

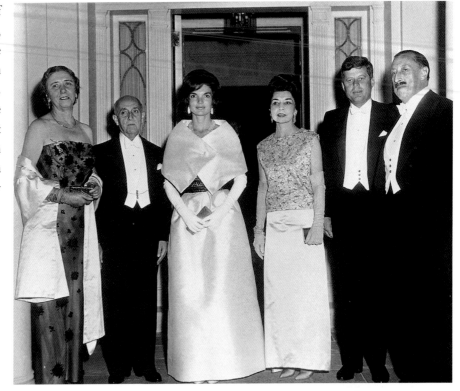

For this dinner in honor of
President Abboud of the
Sudan, the First Lady
engaged the American
Shakespeare Festival to
perform. The dress she
wore, black velvet and
one-shouldered, is a simi-
lar design to the yellow
gown she wore earlier in
the year. Cassini remem-
bers that she often had the
same design repeated in
different materials and
colors.

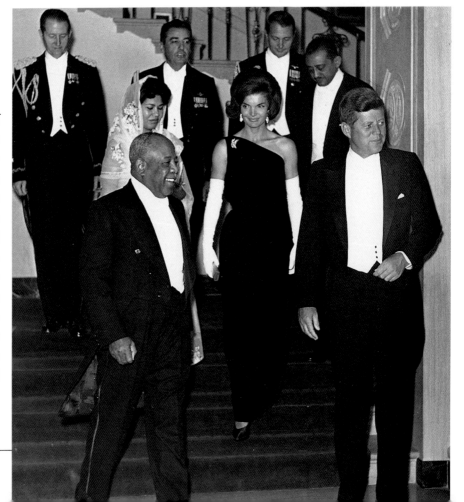

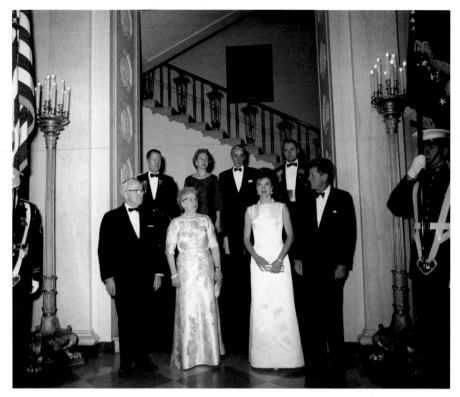

Harry and Bess Truman returned to the White House on November 1, 1961, when the Kennedys hosted a small dinner for them, at which pianist Van Cliburn entertained. Jackie wore an utterly simple white satin gown with a severe bateau neckline. Cassini would later replicate the dress in black silk for her papal visit in 1962.

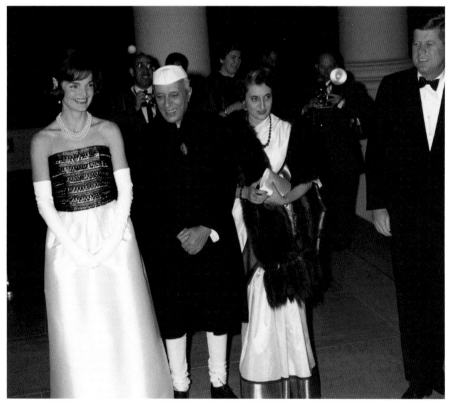

Indian Prime Minister Nehru and his daughter, Indira Gandhi, came to the White House after spending a weekend in Newport as guests of the First Lady's mother and stepfather. They were entertained at a small dinner at which Jackie wore a strapless gown whose bodice was made of black raffia stitched onto white satin. She had worn the dress earlier for a reception at the Peruvian embassy.

Jackie enjoyed a close relationship with Prime Minister Nehru. When she visited India in March 1962, she spoke of spending an hour each day walking with him in his gardens: "We never talk of serious things, I guess, because Jack always told me the one thing a busy man doesn't want to talk about at the end of the day is whether the Geneva Conference will be successful or what settlement could be made in Kashmir or anything like that."

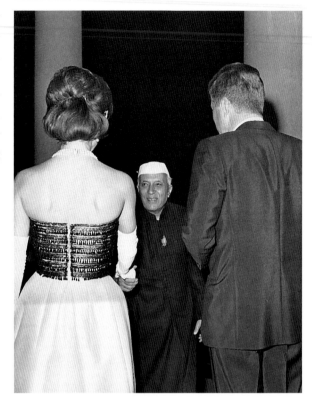

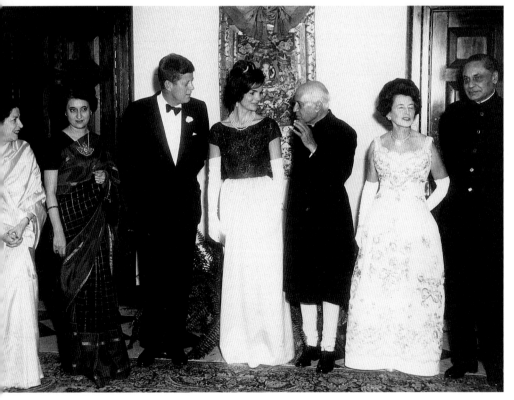

Rose Kennedy enjoyed a unique status: while there was specific protocol for her position as the wife of a former ambassador, her role as quasi–Queen Mother sent the experts scrambling for their etiquette books. She was often a guest at official functions, here attending a dinner at the Indian embassy with her son and daughter-in-law. Jackie's gown, with its black jet-beaded top and plain white satin skirt, would be worn throughout the White House years.

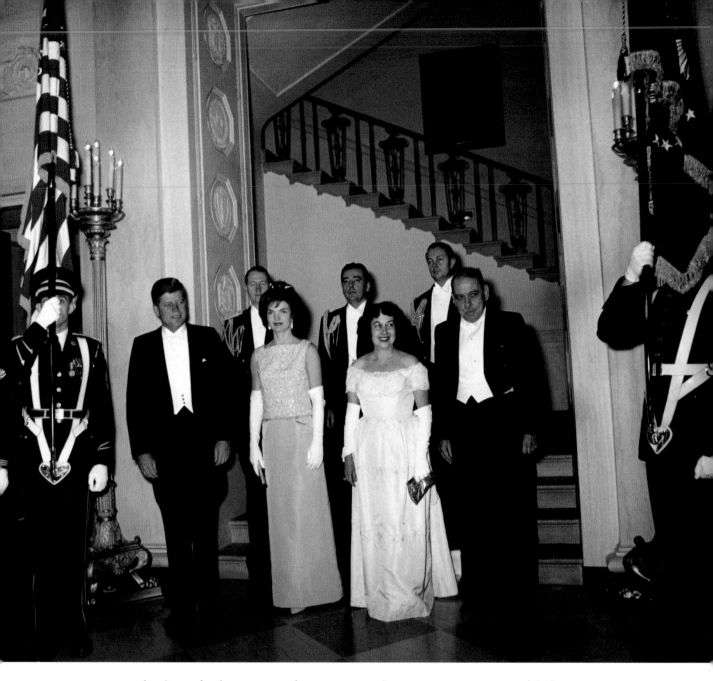

This dinner for the governor of Puerto Rico and Mrs. Muñoz Marín is one of the legendary evenings in the White House. It was the night that cellist Pablo Casals broke his self-imposed exile from performing in a country that recognized Generalissimo Franco of Spain. When President Kennedy, whom Casals deeply admired, personally invited him, he returned to the White House for the first time in nearly fifty years. He had entertained President Theodore Roosevelt in 1904! Alice Roosevelt Longworth, who had been present on that long-ago night, was a guest of the Kennedys, along with some of the most prominent contemporary composers— Samuel Barber, Leonard Bernstein, and Aaron Copland.

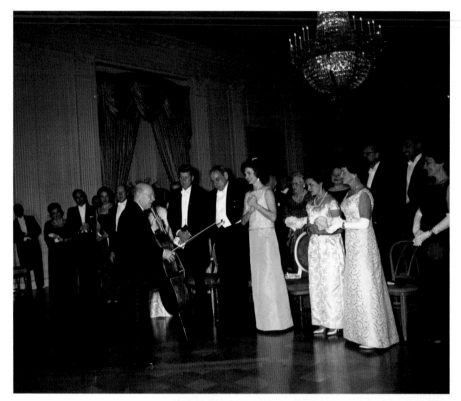

Jackie was exquisitely dressed in a gown of Venetian yellow silk crepe de chine, its bodice decorated with gold embroidery. The bodice fell almost to the hip and was trimmed in golden fringe. She wore diamond wheat-sheaf pins in her hair, diamond pendant earrings, and her wedding-gift bracelet.

Jackie congratulates classical singer Grace Bumbry, who made her American debut at the White House when she was invited by the Kennedys to sing after their dinner in honor of the Vice President, Speaker of the House, and Chief Justice.

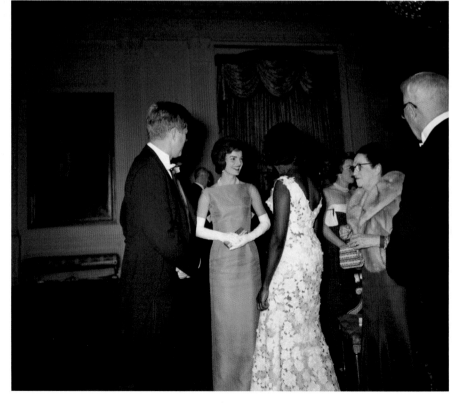

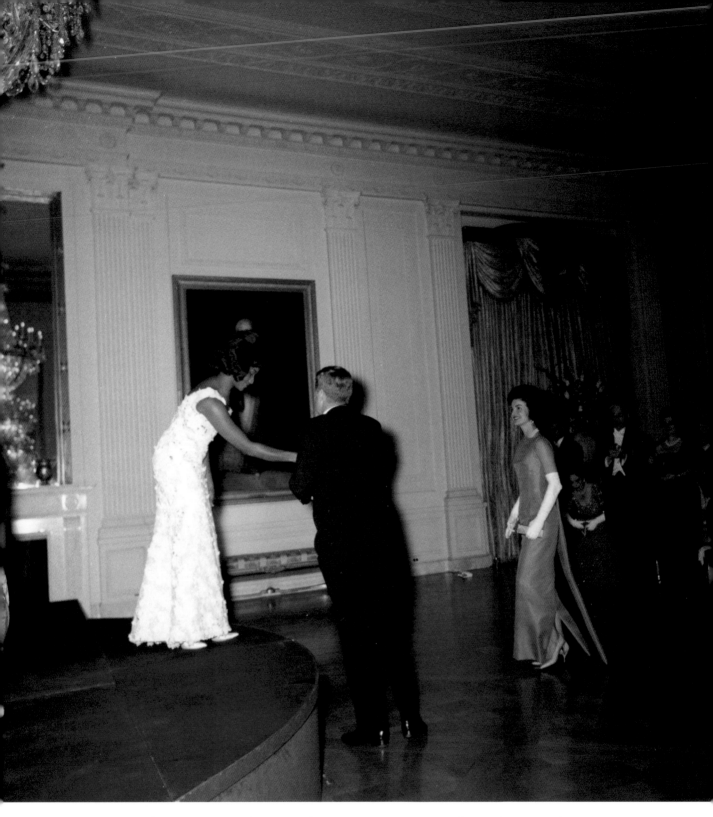

The gown worn by the First Lady was stunning in two regards: its vibrant pumpkin-colored silk and the slight train, which gave it a regal air.

At a fund-raising dinner held on the first anniversary of the inauguration, the First and Second Couples of the land posed for an informal photograph. Jackie's white satin sheath was worn with a heavily beaded bolero jacket. Again, it's fun to contrast the different styles chosen by Jackie and Lady Bird.

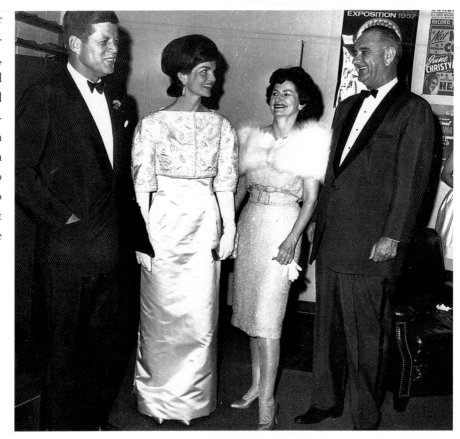

Jackie chats with JFK and Vice President Lyndon Johnson while waiting for the Shah and Empress of Iran to arrive for dinner.

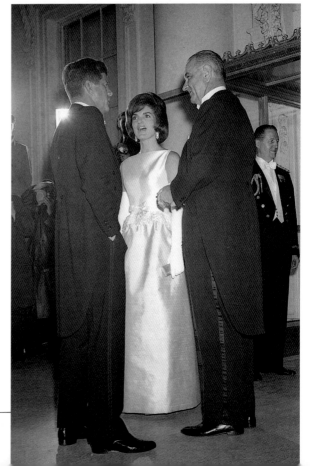

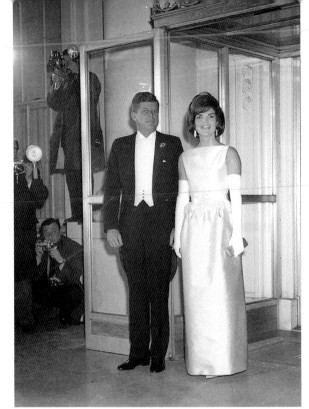

Letitia Baldrige recalls of JFK: "He was very proud of her taste. He loved beautiful clothes. He didn't love all the publicity she got for being a clotheshorse, nor did she. She hated all this attention and the asking how much this or that cost, and how many things she ordered and from where. She just wanted to be well dressed and not have people asking all those questions, and I don't blame her one bit."

Baldrige remembers the night the Shah and Empress came to dinner, and how much JFK enjoyed teasing his fashionable wife. "The night of the state diner for the Shah of Iran, he twitted Mrs. Kennedy by saying, 'You'd better watch out, Jackie. You'd better watch out and see what kind of jewels come out. You'd better put on all your jewels.' So she was borrowing jewels like mad from everybody right and left, trying to come up to Her Royal Highness, Queen Farah. But finally Mrs. Kennedy did a very crafty thing. She took off all her jewels and just put one jewel in her hair . . . and, of course, Farah arrived in a gold embroidered dress glittering with sequins and every jewel in the whole Iranian Kingdom on her back, front and head. And the President just kept laughing at his wife and pointing and saying, 'Are you sure you did the right thing?' And, of course, she had done the right thing. It was very clever, her wearing no jewels at all. The President was very cute because he kept saying, 'You know, she's pretty good looking, Jackie, and that dress is pretty good. I bet her clothes bill is more than yours.'"

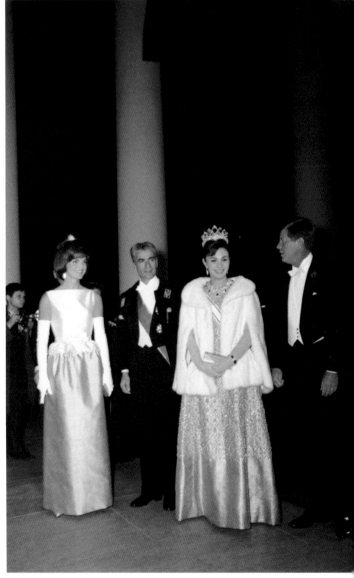

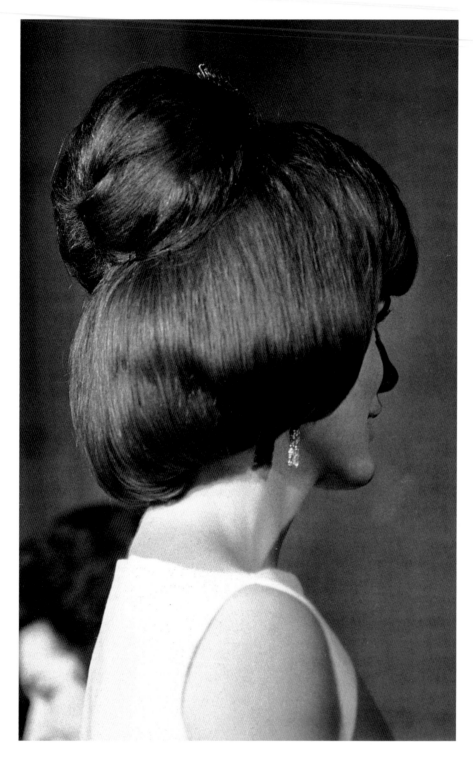

Jackie's elaborate new hairdo was named a "brioche," perhaps after the French pastry. Yet in its stiffened, elaborate, and totally artificial perfection, it more closely resembles a wig from a Kabuki theater piece.

The writer Diana Trilling was a guest at the dinner honoring all the Nobel Prize winners in the Western Hemisphere on April 29, 1962. In her notes on the evening, later published in *The New Yorker*, she wrote, "They had just come back from the Palm Beach vacation, and they were very suntanned. Jackie was a deep cocoa brown, and she was wearing a sea-green chiffon dress, to the floor, but cut very simply except that it had one bare shoulder. She wore green slippers to match her dress and no jewelry at all except some earrings, which were the most beautiful shade of green. Her dress really wasn't cut very elaborately, but it had millions of pleats. Hers was a charming figure rather than a perfect one, and she carried her clothes exquisitely. . . .

"She was a hundred times more beautiful than any photograph had ever indicated. . . .

"Jackie's basic courtesy is sharply developed. . . . It's learned courtesy, totally conscious, not imperiled by champagne."

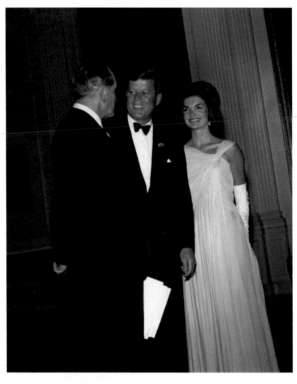

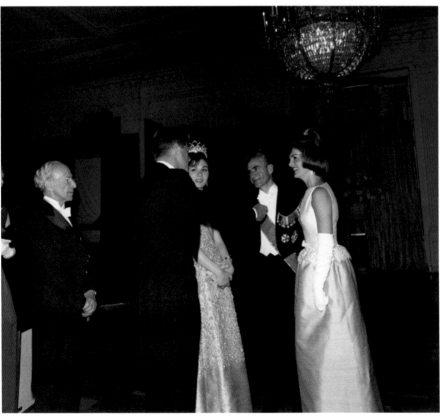

"Mrs. Kennedy played it just right. She wore a pale pink and white dress of shiny, stiff silk, very *jeune fille*. She wore a simple pair of diamond earrings and one diamond spray embedded in her brioche hairdo. The effect was one of total simplicity and understatement."
—Letitia Baldrige, *Of Diamonds and Diplomats*

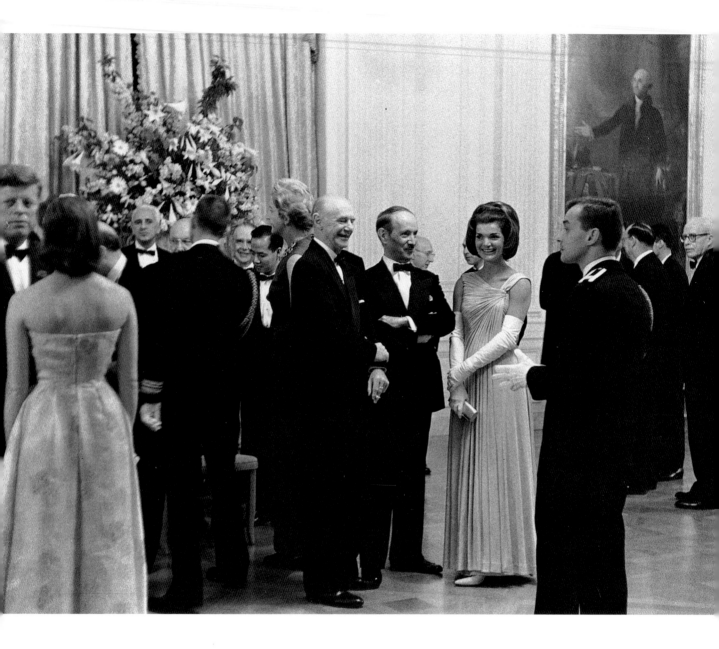

At an after-party in the Kennedys' private apartments, Jackie gossiped with Lionel Trilling about White House entertaining: "We used to have to come to the White House when Jack was a Senator and the Eisenhowers were here. It was just unbearable. There would be Mamie in one chair and Ike in another . . . and everyone stood and there was nothing to drink. During that regime there was never anything served to drink, and we made up our minds, when we came to the White House, that nobody was ever going to be as bored as that. We do try to make it a good party."

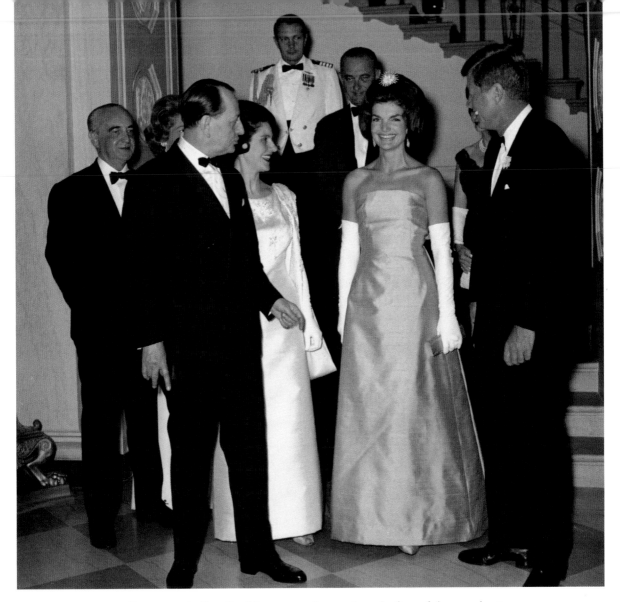

Jacqueline Kennedy literally shimmers as she stands at the foot of the grand staircase, the cynosure of all around her. JFK gazes at her adoringly; André Malraux and his wife turn to her, and even LBJ behind her seems transfixed. This evening at the White House was a triumph for Jackie. In honoring Malraux, France's Minister of Culture, she brought support of the arts to the forefront of public consciousness—in truth, laying the foundation for what would eventually, under LBJ, become the National Endowment for the Arts. Guests at this dinner included George Balanchine, Leonard Bernstein, Elia Kazan, Andrew Wyeth, John Hersey, Charles Lindbergh, Arthur Miller, and Tennessee Williams. It represents, in one evening, many of the goals that Jackie strove to achieve during her tenure as First Lady.

She looks ravishing—tanned, fit, glowing with health and happiness. Her silk douppioni gown glimmers, and the eighteenth-century diamond starburst in her hair truly anoints her as "America's Queen."

Madame Houphouët-Boigny, wife of the President of the Ivory Coast, was nicknamed "Africa's Jackie," and she earned that sobriquet in a white satin gown designed by Pierre Balmain, richly embroidered in gold and bugle beads. Jackie's white gown glistened with silver sparkles, crystal beading, and brilliants. The form-fitting sheath eased at the hem, allowing for a small train effect.

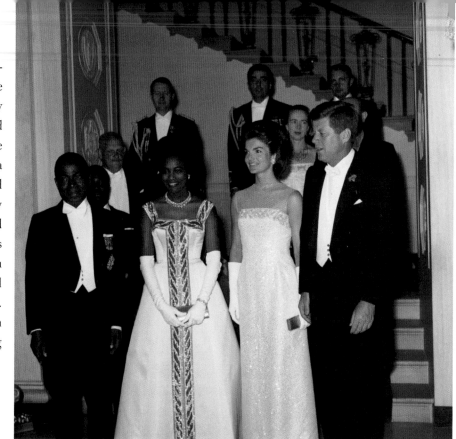

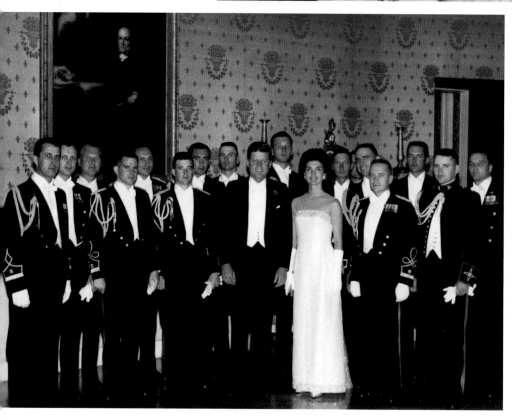

The President and Mrs. Kennedy posed with the White House military aides. These young men were assigned to keep the evening running smoothly. One dinner guest recalled a young man offering his arm: "'I'll be your aide for the early part of the evening. You'll be told everything you have to do, so you needn't feel any constraint at all.' There must have been eighteen or twenty such aides, each in charge of eight to ten people. But there was no pressure of any kind. Just the contrary."

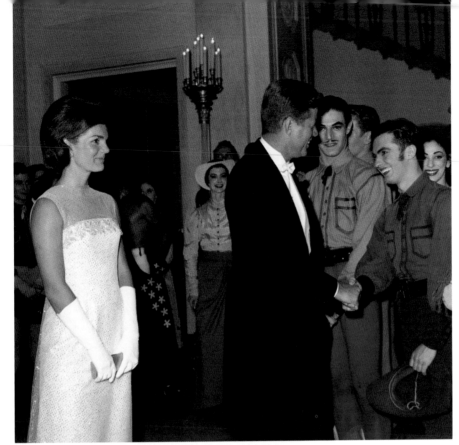

The entertainment after dinner was a performance of *Billy the Kid* by the American Ballet Theatre, an institution close to Jackie's heart. The ballet's composer, Aaron Copland, was a guest at the dinner. Here the President congratulates one of the dancers as Jackie beams.

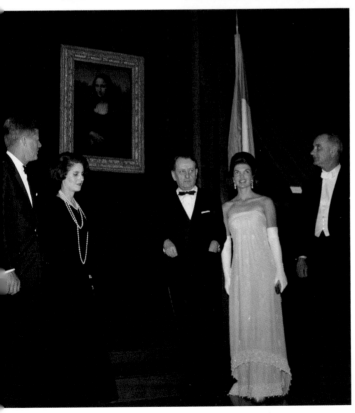

Another of the cultural highlights of the Kennedy administration was the visit to Washington of France's most famous lady, *La Gioconda*, known also as *Mona Lisa*. André Malraux, as a result of his admiration for the Kennedys, arranged to lend da Vinci's masterpiece personally to the President, as opposed to the National Gallery of Art, where the painting would be on exhibit. Jackie wore an elaborately designed gown of pale mauve silk chiffon, embroidered with hand-sewn crystal beads. The overskirt had a raised hem that fell to a small train in the back. The underskirt was also beaded at the hem to match. Oleg Cassini recalls, "Some dresses are conspicuously successful, and this was one of our favorite gowns."

Can you imagine how incredibly *seductive* it must have been to have the glamorous Jacqueline Kennedy, exquisitely dressed, leaning into you and whispering in your ear, with that feathery voice, in perfect French? Is it any wonder that André Malraux dedicated his 1967 book, *Anti-Memoirs*, to her?

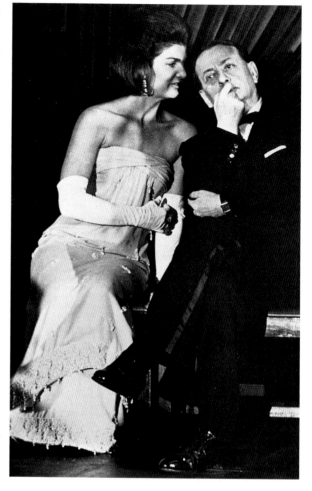

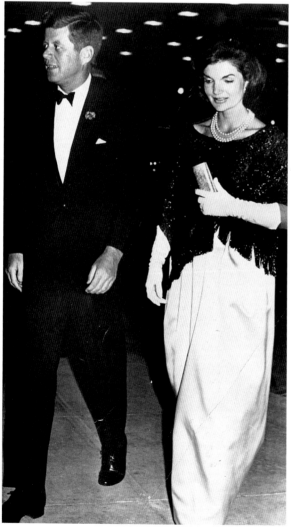

At a dinner in honor of the second anniversary of the inauguration, Jackie dug this two-year-old gown out of her closet. Its heavily beaded bodice had a matching fringed stole that she wore, along with her famous pearls (thirty years later we would find out they were fake!) and a gold evening purse.

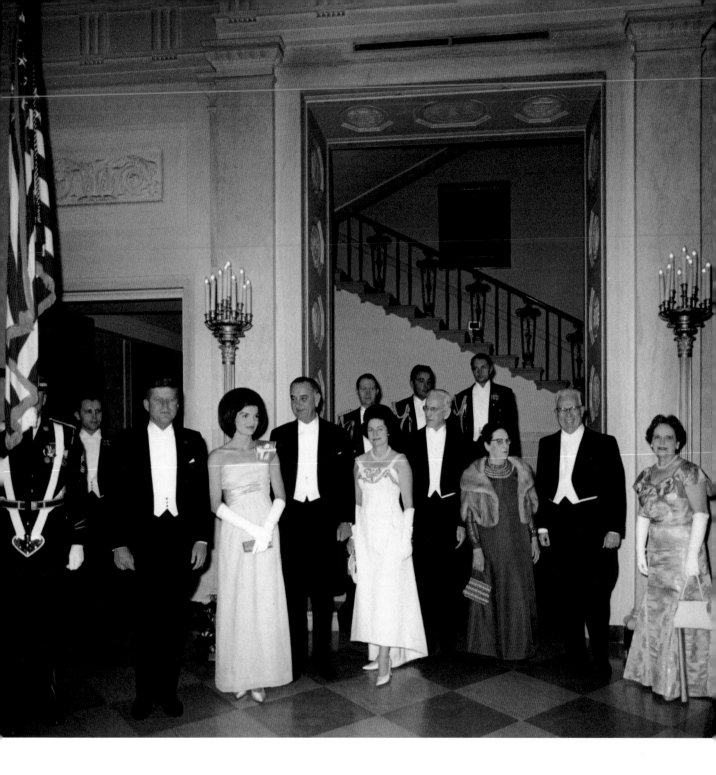

This yummy citron yellow gown, mixing silk chiffon and satin, was inspired by the turbans worn by men in Rajasthan, India, which Jackie had visited the previous spring. It was worn for a dinner honoring the Vice President, the Chief Justice, and the Speaker of the House in January 1963.

Jackie wore black chiffon for a dinner honoring Venezuelan President Rómulo Betancourt, whose wife seems to be wearing one of Oleg Cassini's one-shouldered dresses popularized by the American First Lady. The black chiffon was pleated into a slim column, accented by satin ribbons at the waist and below the bustline. Jackie would wear this gown often after she left the White House.

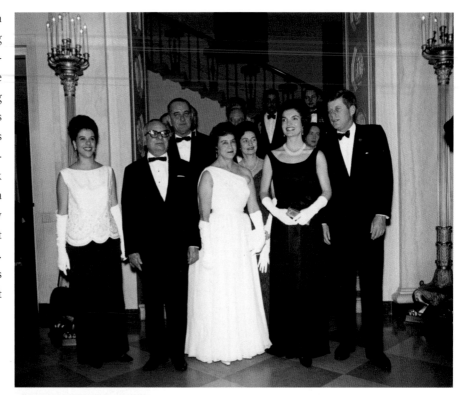

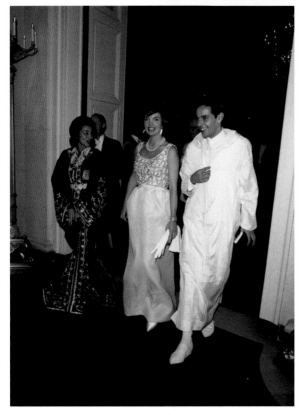

Seen here with Princess Lalla Nezha and Prince Moulay Abdallah of Morocco after a state dinner honoring King Hassan II, Jackie glows with an undisclosed secret—she was three months pregnant. The bodice of her white satin gown is embroidered with pink and silver brilliants and stones. On her wrist she wears a gem-encrusted gold bracelet that was a gift from the King. The evening's entertainment was an abridged perfomance of the musical *Brigadoon*, and the guests included the show's librettist, Alan Jay Lerner (a prep-school classmate of JFK's), as well as Samuel Barber, Agnes de Mille, and movie star Myrna Loy.

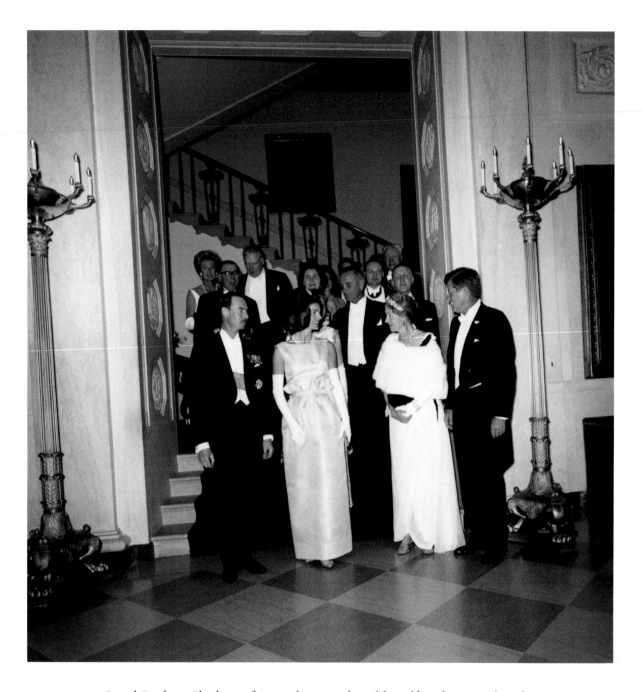

Grand Duchess Charlotte of Luxembourg endeared herself to the Kennedys when she told them, "I read today that it's chic to be pregnant." News that the First Lady was expecting a child that fall had just been released, and this was an exceptionally happy time for her. Jackie's sleeveless gown featured an unusual waist detail, ruffles feathered above the waist and gathered with a simple bow. It was made of the palest mauve-pink silk, and she wore her pearls and her favorite eighteenth-century starburst diamond pin in her hair.

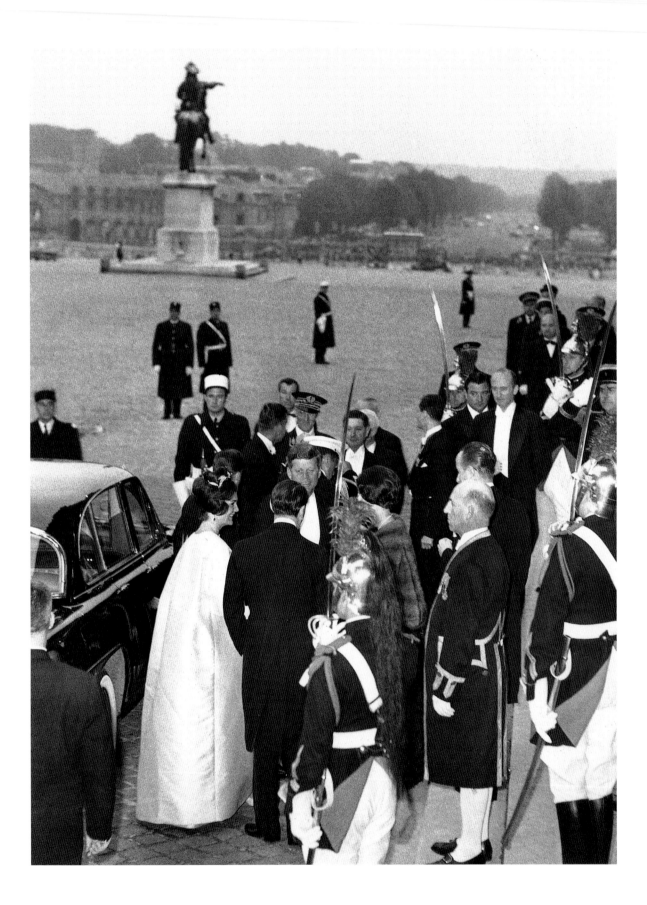

Foreign Travel: Representing America Abroad

Mrs. Kennedy's wardrobe was the talk of everyone, from the cheesemakers in Roquefort and the bar waitresses in the Yukon to the pearl divers in Japan. Her clothes were sensational, as they should have been for a Paris state visit.

—Letitia Baldrige

Jacqueline Kennedy traveled more than any previous First Lady. There were state visits to France, Austria, England, Colombia, Venezuela, and Mexico. She also made semi-state visits to Italy, India, and Pakistan, as well as private trips to England, Italy, Greece, and Morocco. These trips were carefully orchestrated both to promote the policies of the Kennedy administration and to underscore America's position as the great democratic power to allies in Europe and throughout the Western Hemisphere. The First Lady's elegance was matched by her love of history and her ability to communicate, often in their native tongue, with people around the globe. It was said she surpassed Coca-Cola as a popular export and was more effective in easing diplomatic tensions than a river of martinis.

Initially, it was difficult to be on continual display. "I greet Jack every day with a tear-stained face," she confessed to Gore Vidal. Advice would come from, of all people, Queen Elizabeth II, who comforted the First Lady over dinner: "One gets crafty after a while and learns how to save oneself." She learned quickly, and almost instantaneously became an international sensation.

Everywhere they went, people clamored to see them, to see her, and to see what she was wearing. Enormous care was put into these traveling wardrobes. Trunk after trunk, each carefully packed with costumes and accessories, accompanied her on each trip. Press reports focused so much on her clothes that her wardrobe sometimes undermined the real purpose of the trips. An appropriate wardrobe was something she considered necessary but nothing she wanted to dwell on. When asked about the quantity of her luggage by the magazine *Jours de France*, Jackie replied, "It is as indiscreet as to ask a lady her age." After the trip to France, the White House stopped issuing press releases about her clothes, and on the trip to India stopped answering sartorial questions altogether. Because of the heat, and the need to change frequently, the India/Pakistan wardrobe was enormous. Brilliantly designed in vivid Indian colors—hot, bright pinks and blues and greens, as well as serene whites and ivories—it was ecstatically received and endlessly reported on. She had become a global ambassador of style.

This was clearly demonstrated in Paris, where JFK was so impressed by her popularity that he charmed the world by introducing himself by saying, "I am the man who accompanied Jacqueline Kennedy to Paris, and I have enjoyed myself."

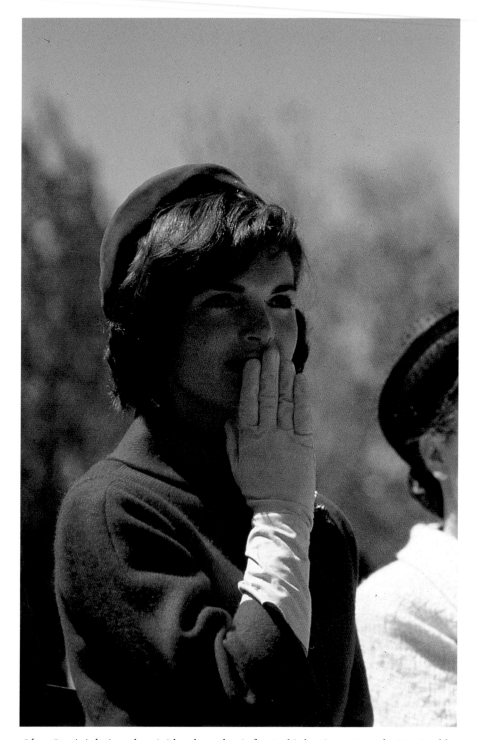

Oleg Cassini designed a vivid red wool suit for Jackie's trip to Canada. Inspired by the uniforms of the Royal Canadian Mounted Police, it featured a buttoned ring collar, three-quarter sleeves, a fitted jacket, and a slim skirt that just grazed the bottom of her knees.

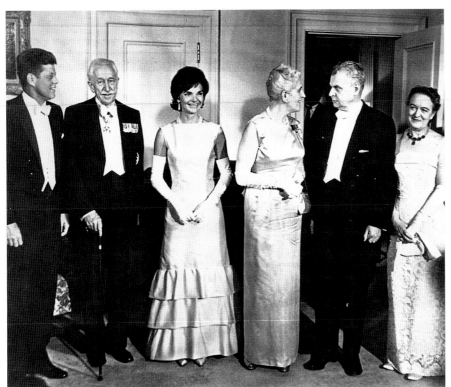

This fussy dress was an experiment on Jackie's part and problematic from the start. Originally created in orange organza, it did not please, as Jackie wrote to Cassini on March 20: "I return the other costume you made me for Canada—as the color is not so good for me.... Remember I thought of pink." He redid the gown in a Watteau pink silk, but the tiers of ruffles were not repeated in the future and the dress was not seen in public again.

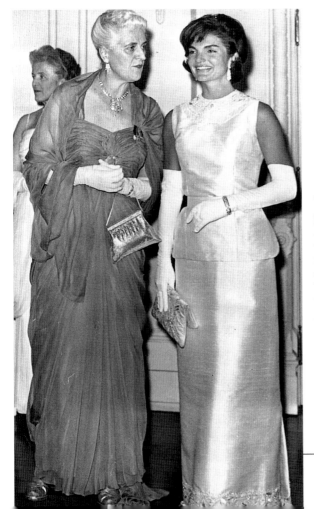

Tish Baldrige recalls that the trip to Canada "was the beginning of her popularity and I think he [JFK] really looked at her with new eyes on this occasion. She took far too many suitcases and hair dryers and whatnot and he was impatient . . . with all this extra stuff along, but then he realized it was all a very important part of her image of impeccable grooming and beauty and style and he was very proud of her and of the lavish descriptions of her personal appearance. So his criticism of all those suitcases and the confusion of the hair being washed was greatly reduced after that."

Chapeau in hand, Jackie prepares to board *Air Force One* for the overnight trip to Paris, where international acclaim would soon envelop her.

It was a bright sunshiny morning when the Kennedys arrived in Paris, and Jackie actually glistened in a jonquil yellow suit that came to typify the "Jacqueline Kennedy look." Its clean lines, subtle details, sumptuous fabric, and simple accessories made it a standout. Jackie is wearing a much-loved pair of Jean Schlumberger enameled bracelets from Tiffany's that had been a birthday present from her husband.

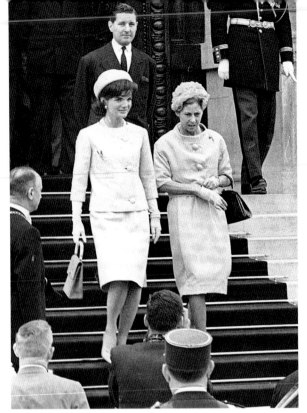

Oleg Cassini was known, in the parlance of *Women's Wear Daily*, for his "sexy little numbers," and that's clearly evident in this picture of Jackie leaving the Quai d'Orsay with the wife of the American ambassador to France. Her feminine allure is heightened by the subtle shaping of her jonquil yellow suit, and her sensuousness is evidence in the way she caresses her handbag with her fingertips. But then, she was on her way to seduce not just de Gaulle, not just France, but the entire world.

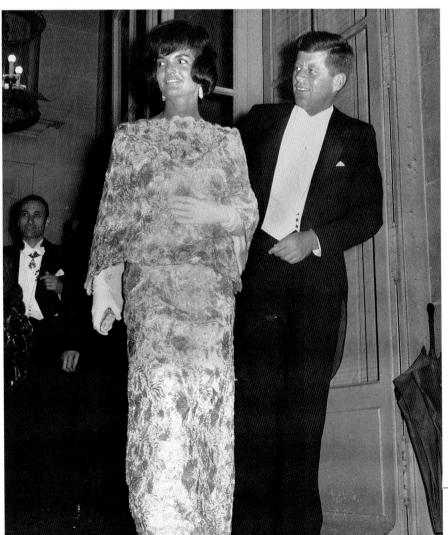

"There were certain dresses that he liked very, very much. He loved an Oleg Cassini one, a pink and silver lace. It was a Dior fabric and she wore it to General and Madame de Gaulle's reception. He very much liked that dress and told her to wear it often and she did. She was very sensitive to his likes and dislikes in clothes."
—Letitia Baldrige

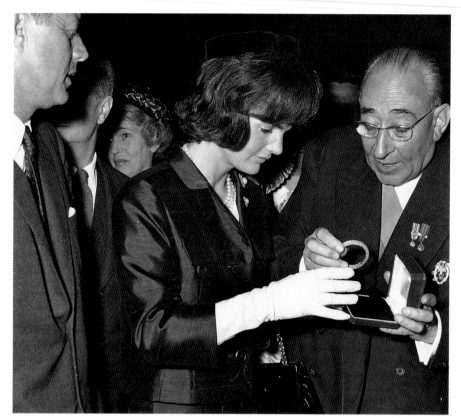

Jackie examines, with delighted intensity, a four-thousand-dollar gold watch presented to her by Julian Tardieu, president of Paris's municipal council. She is wearing a Givenchy-designed navy silk suit.

As a young woman, Jacqueline Bouvier had studied in France, and her knowledge of and passion for French history captivated Charles de Gaulle. He told JFK that "your wife knows more about French history than most Frenchwomen." Yvonne de Gaulle didn't make as deep an impression on JFK. At an official luncheon, and at a rare loss for words, he complimented her on the centerpiece. She sniffed and replied, "We had a much better one yesterday."

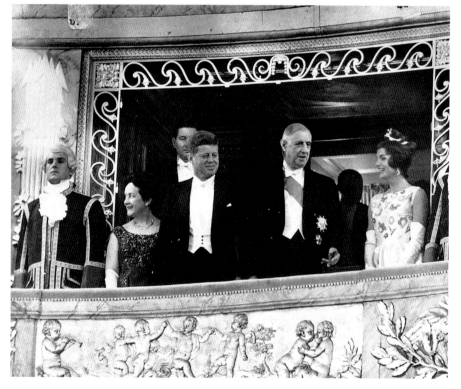

The grandeur of it all . . . JFK and Jackie share a brief conversation in the Palace of Versailles.

Jackie wore several diamond clips in her elaborate hairstyle; they fashioned a tiara-like halo. It's possible to see some of the elaborately embroidered flowers that decorated the bodice of the gown.

A strong friendship was born on this trip between Jacqueline Kennedy and André Malraux, seen here visiting Malmaison, the country retreat of Empress Josephine. The First Lady was both charmed by him and touched that he would escort her only days after the accidental deaths of his two young sons. She wore a gray wool suit with a fringe trim on the collar and down the front of the jacket. Her white elbow-length gloves match her white beret.

This cartoon, of Charles de Gaulle dreaming of Jacqueline Kennedy, much to his wife's dismay, appeared in a French newspaper during the trip and was given to Jackie, at her request, as a souvenir of her trip to Paris.

...Charles!

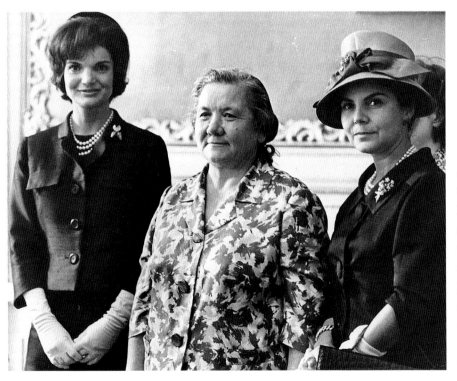

A reporter in Vienna described the American First Lady as "looking like a fashion magazine illustration," while Mrs. Khrushchev resembled "the housewife for whom fashion magazines are illustrated." Jackie wears the same navy silk suit she had worn in Paris.

This striking blue wool suit, with the red roses and white gloves, made a patriotic tableau in Vienna.

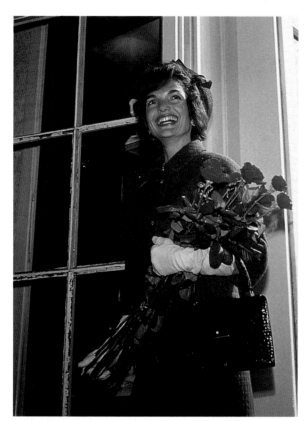

This dress was originally planned for the inaugural festivities but made its debut at the formal dinner at the Schönbrunn Palace that marked the Vienna summit. It was glimmering, made of silver-gray silk embroidered with pink beads, and effortlessly caught the light. Khrushchev's comment? "It's beautiful," he declared.

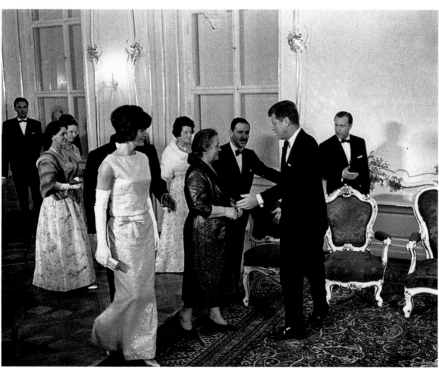

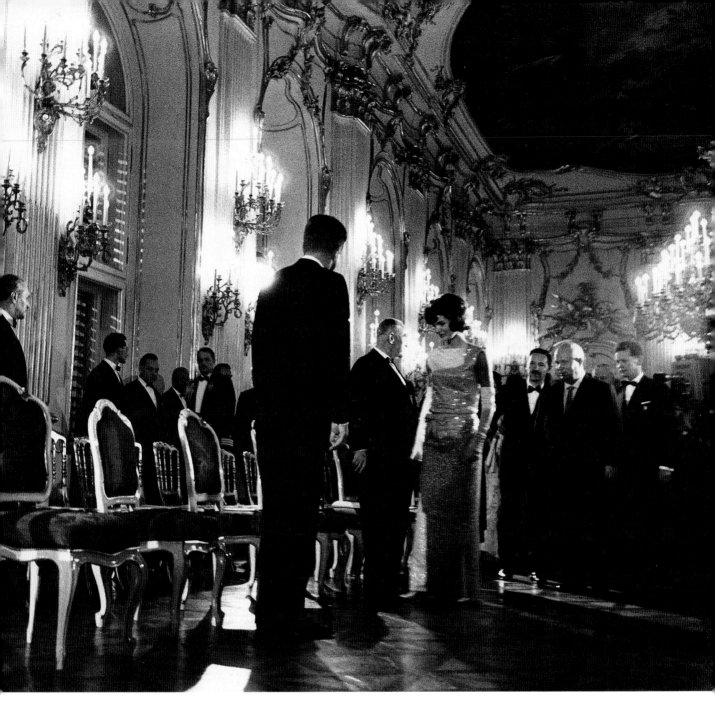

"I was sick with nervousness. I didn't know what I would talk to him about, and I kept asking Jack, 'What shall I say to him? What do I talk about?' I kept sitting there wondering what would be an innocent subject of conversation, and I decided to talk about animals. I said, 'I just love Russian dogs.' I asked him to send me one, and he did. Jack was furious with me for giving him such a diplomatic advantage."
—Jacqueline Kennedy, on meeting Nikita Khrushchev

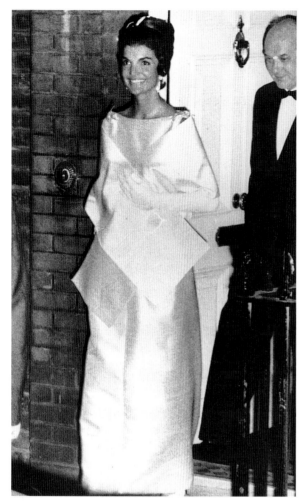

Left: Followed by Secretary of State Dean Rusk, Jacqueline Kennedy emerges from her sister Lee Radziwell's London home en route to dinner at Buckingham Palace with the Queen. She is wearing an ice blue satin dress with a bateau neckline, diamond clips on both shoulders, and a matching shawl. The Queen relaxed royal protocol by inviting Lee and her husband, Prince Stanislaus Radziwell: both Radziwells had been divorced, a taboo at the time, plus the Queen had never given her consent for him to use his Polish royal title in Britain. It was a mark of Her Majesty's courtesy, but as Jackie slyly noted to Gore Vidal, describing the dinner guests, "the Queen got her revenge. No [Princess] Margaret, no Marina [Duchess of Kent], no one except every Commonwealth minister of agriculture they could find."

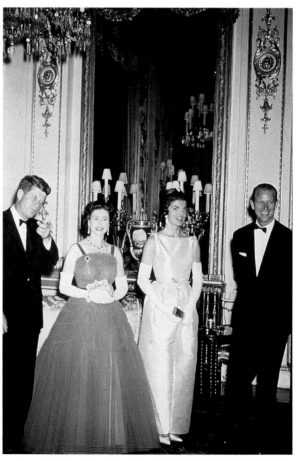

Right: In his published diaries *1955–63: The Restless Years*, famed photographer Cecil Beaton recorded his dinner with an off-duty Jacqueline Kennedy: "The Jackie evening was interesting in some ways. It was to be the one informal evening in a week of triumphant European official visits for the wife of the American President. Jakie Astor and his wife Chiquita gave a small dinner party for her (apart from the Radziwells, just the William Douglas-Homes and me).

"Jackie was outspoken and impolitic. . . . About dinner with the Queen last night she said they were all tremendously kind and nice, but she was not impressed by the flowers, or the furnishings of the apartments at Buckingham Palace, or by the Queen's dark blue tulle dress and shoulder straps, or that flat hairstyle."

For a lunch with Prime Minister Macmillan, Jackie wore the yellow suit seen earlier that week in Paris. She trades her pillbox for a lacy straw hat. The Prime Minister's wife, Lady Dorothy Macmillan, was the aunt of President Kennedy's sister Kathleen's husband, Billy Hartington, who was killed in World War II.

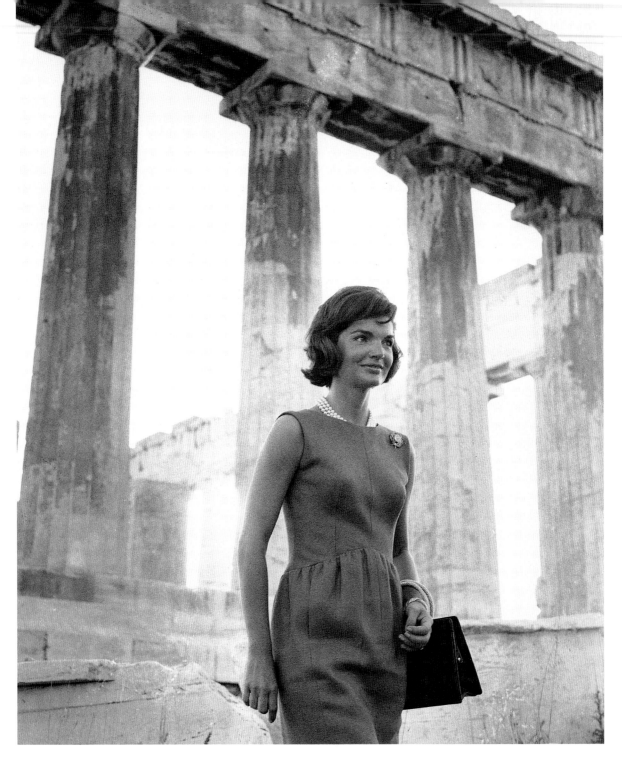

After London, JFK went back to Washington while Jackie and Lee went to Greece for a week's vacation. Seen here at the Parthenon, Jackie fell in love with Greece and told reporters, "This land is a miracle. It's like a dream. . . . I am literally enchanted with your clear blue sky, as well as your beautiful sea. . . . Everyone should see Greece. . . . My dream is to have a house here to spend vacations with my children."

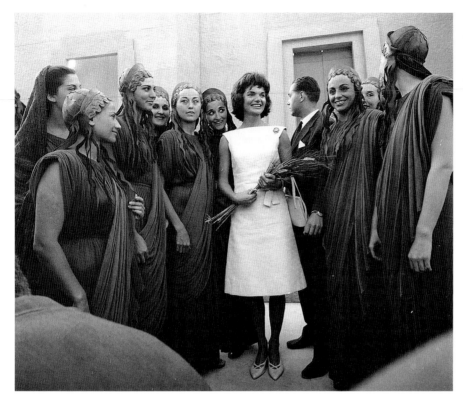

In a simply cut dress of white ribbed silk, Jackie attended a rehearsal of *Electra* in the 2,500-year-old theater at Epidaurus, and afterward talked with the actors.

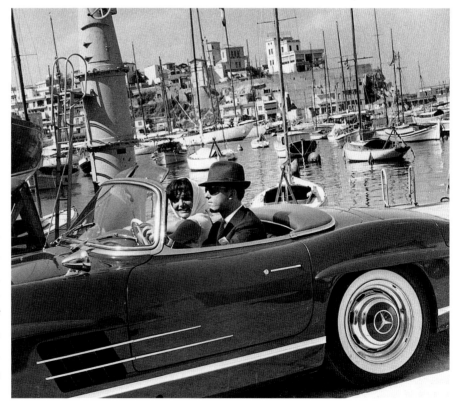

The then Crown Prince Constantine of Greece takes Jackie for a spin in his Mercedes convertible around the harbor of Torkolimano, where the twenty-one-year-old future King kept his Olympic sailboat.

In December 1961, the
Kennedys traveled to
Puerto Rico, where they
were entertained at a re-
ception given by Gover-
nor and Mrs. Muñoz
Marín. Jackie wore a
claret-colored wool dress
whose main feature was
an asymmetrical looped
tie at the neckline.

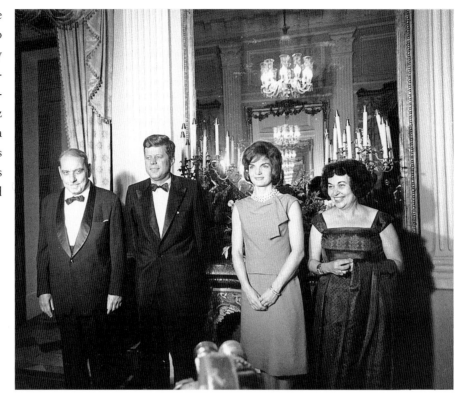

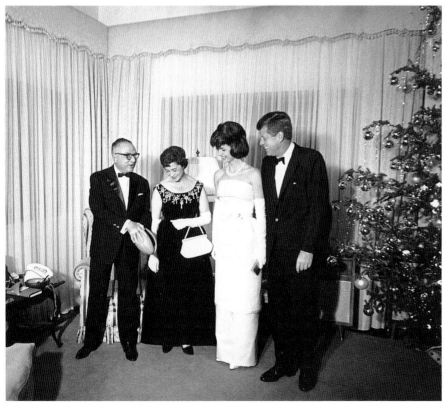

This gown of ivory silk
gazar made its first
appearance in Venezuela,
at a dinner held in honor
of the visiting American
President. The dress is
trimmed at the bust, waist,
and overskirt in satin rib-
bon. While an elaborate
dress with several compo-
nents, its effect, like that
of her inaugural-ball cos-
tume, is one of simplicity.

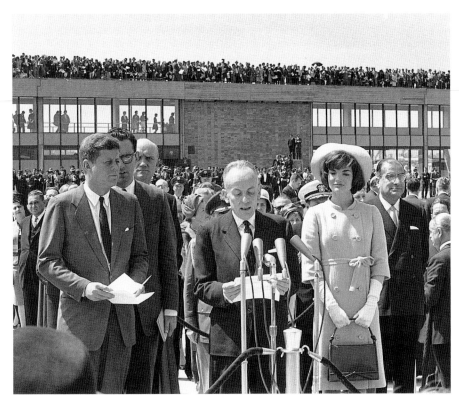

"As it must to all women, a run came Sunday to the stocking of Mrs. John F. Kennedy. It showed up on the First Lady's ankle when she mounted the speaker's stand at El Dorado airport on her arrival in Colombia. She seemed unaware of it." So trumpeted the Associated Press to the world on December 17, 1961.

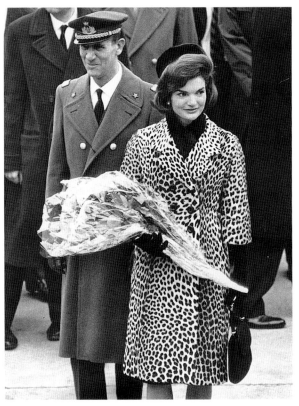

March 1962 found Jackie fulfilling a lifelong dream and traveling to India with her sister, Lee. Their first stop was a short stay in Rome; she's shown here upon her arrival, wearing a coat made from rare Somali leopard skins. Furrier Ted Kahn, a Harvard classmate of JFK's, arranged for the trade-in of one of Jackie's old mink coats. Her selection of the leopard caused a mad rush for the rare pelts and a decline (albeit temporarily) for mink!

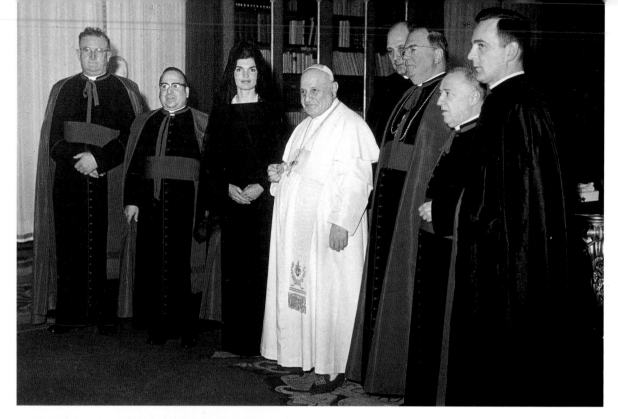

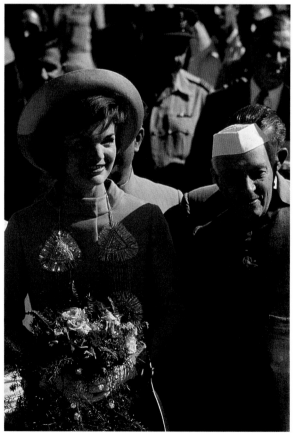

On visiting Pope John XXIII in March of 1962, Jackie said, "He's such a good man—so of the earth and centuries of kindness in his eyes. I was determined to curtsy three times on the way, as you're supposed to do. I did one, and then he rushed forward, so I barely got in one more curtsy. I read in the papers I had an unusually long audience, but it didn't seem long. It was all so simple and natural. We didn't talk of anything serious." Cassini whipped up a replica of the white dress designed for the Truman dinner, but in black silk with long sleeves added to conform with Vatican protocol.

When asked her impressions of India, Jackie responded: "Fabulous splashes of color, the exotic sights and smells, the profusion of flowers everywhere, and the sea of beautiful, fascinating faces."

Jackie confessed to a friend that just prior to her departure for Asia, "Jack spent the whole last day of his vacation screaming over the telephone on a poor connection with Ken Galbraith, telling him he had to shorten the schedule. He was so busy and yet he spent his whole last precious day of rest helping me."

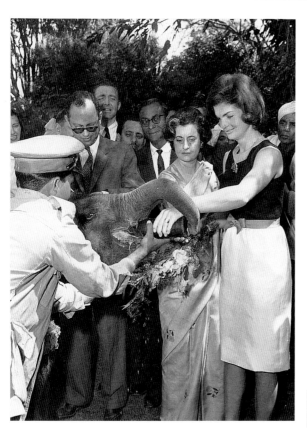

Feeding a baby elephant with Indira Gandhi, Jackie wore a dress designed by Donald Brooks with a navy bodice, white skirt, and lime green trim.

With her feet wrapped in cloth covers, Jackie prepared to visit the tomb of the Muslim holy man Cristi. She is wearing a simple cotton dress in a bright blue-and-green print. In preparation for the trip, she had written to Cassini: "It turns out India is so hot, one has to change clothes about 3 times a day. I am not going to fuss with clothes anymore for there—but I thought if you had any washable cotton dresses in your new collection—suitable for public appearance—a couple of them would be great. Just send me the regular size 10."

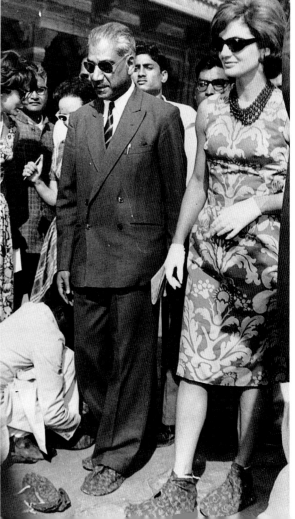

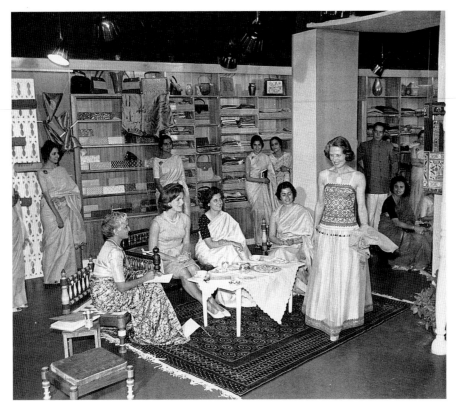

Though Jackie tried hard not to be seen at fashion shows when traveling abroad (in Paris she refused numerous invitations, saying she had more important things to do), when she could bring attention and focus to an economically depressed area, she was more than willing to help. Here she and future Indian Prime Minister Indira Gandhi watch Ambassador Galbraith's wife model a dress made of Indian fabric.

Here the First Lady wears an Oleg Cassini gown previously worn in Caracas, Venezuela, in December 1961. Cassini remembers that "she could carry the clothes beautifully, and by that I mean she had good posture, wide shoulders, narrow hips, a long waist, but also that she *believed* in the clothes, she wore them with confidence."

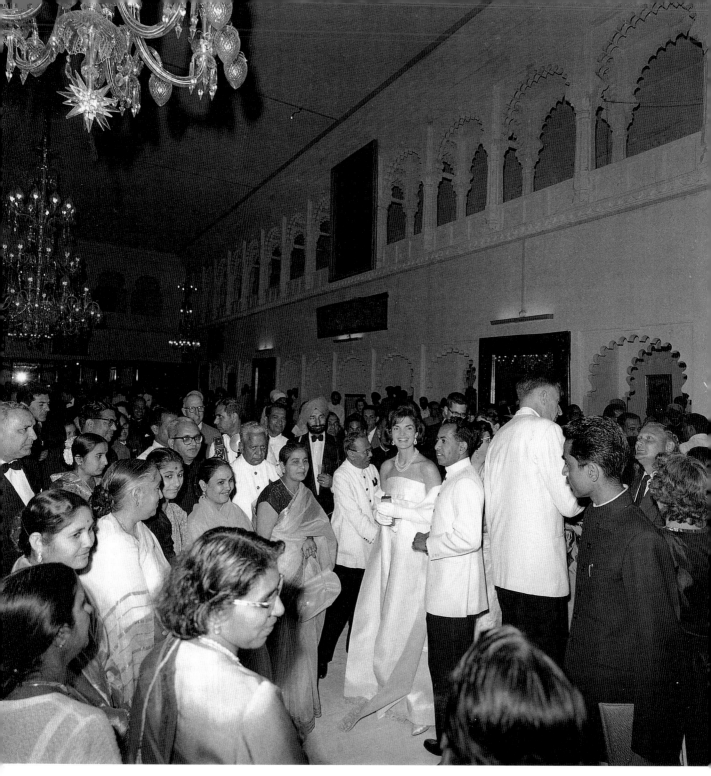

Determined that her trip not be turned into a traveling fashion show, Jackie was dismayed when the press asked about little else than her wardrobe. She told her press secretary, "If you say anything, tell them it's secondhand and that I bought everything at the Ritz Thrift Shop."

"She would write letters to the heads of state, friendly, social, chatty letters when things were going wrong and, of course, we would go wild in the East Wing because we didn't have carbon copies and we didn't know what she was saying. She would write handwritten letters and go on for pages and pages to General de Gaulle and Prime Minister Nehru and all. But this was her working with him upstairs and seeing how she could help in her way to further the political gains of the United States of America and its foreign policy."
—Tish Baldrige, on her boss (seen here with Nehru)

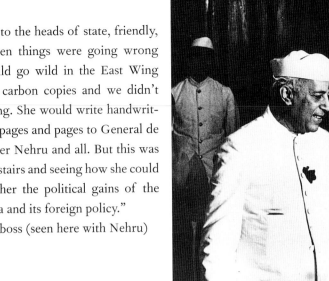

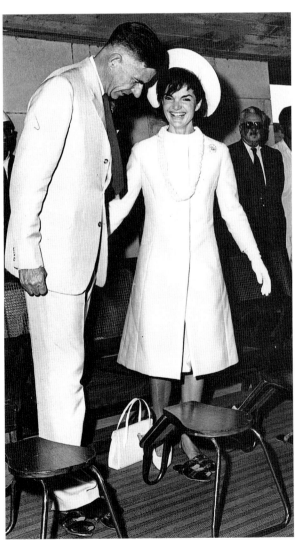

Jackiemania in the press reached a new height when Keyes Beech of the *Chicago Daily News* filed this exclusive from New Delhi: "This reporter is now able to lift the veil of secrecy from Jacqueline Kennedy's feet. I can state with absolute authority that she wears 10-A size shoes—not 10-double-A as previously reported. I know this because I did a sneaky thing. I looked inside Jackie's shoes when she visited the Mahatma Gandhi memorial yesterday afternoon. She had to take off her shoes and put on sandals when she entered the memorial enclosure, which is considered sacred ground. These shoes were Italian made by 'Mario and Eugenia of Florence.' Having no tape measure, I was unable to measure the exact length of the heels. However, my rough estimate would be two inches."

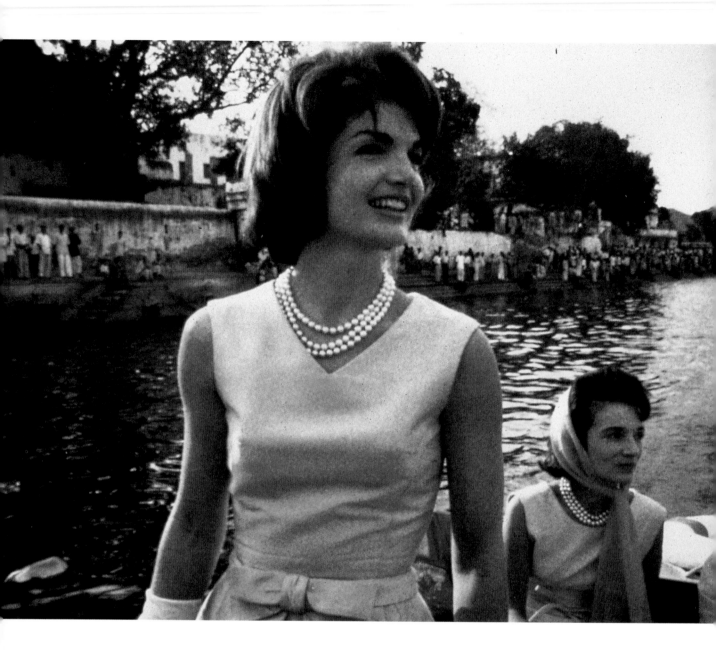

"She must have studied terribly carefully. Every dress she wears becomes a marvelous spot of color, like the bright spot that holds your eye in Persian miniatures. The pale apricot silk she wore for the boat ride on Pichola Lake was wonderful against these pink-tinged castles in the water," an admiring journalist told Jackie's friend Joan Braden for the *Saturday Evening Post*.

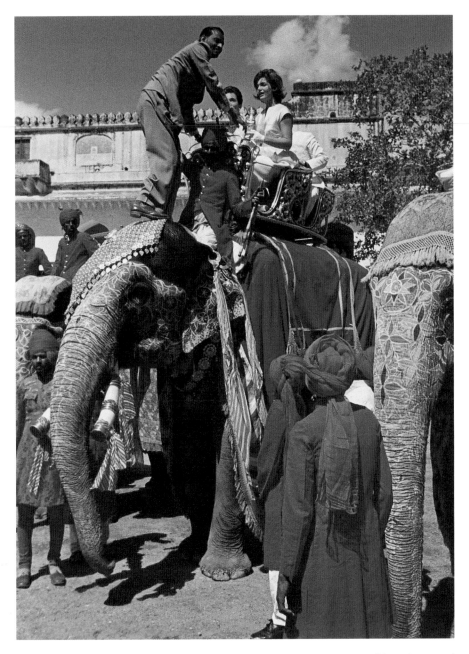

Jackie and Lee enjoyed, if that's the right word, a ride on an elephant (as Lee told Barbara Walters, who, as a young reporter, accompanied the First Lady and her sister to India, "You don't feel very graceful on top of an elephant!").

On the flight home, Jackie shared some of her traveling beauty secrets with friend and reporter Joan Braden: "For months before we left [her maid] Provi learned from Jean Louis every Friday how to set hair. Lots of times on the trip, instead of taking a nap, I washed my hair and Provi put in the rollers. I can't do that but I'm pretty good at combing. I did think of taking a wig but I couldn't find one that looked natural. The one night I did try one, when I walked into the room Jack said, 'My God, what have you done to yourself?'"

President Ayub Khan of Pakistan escorts Jackie to a reception at the Presidential palace. The brightly striped marquee and bold red carpet are a perfect foil for her simple pale yellow suit, which had a jewel neckline, large covered buttons on an off-center closure, and, unusual for her, full-length sleeves.

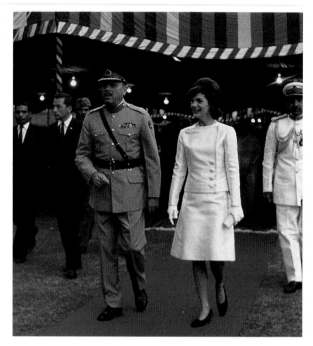

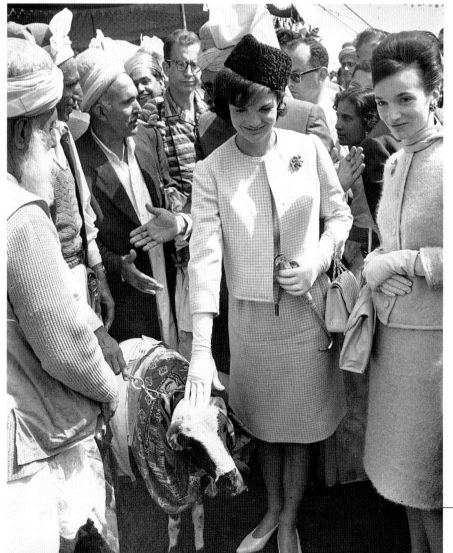

Wearing an Astrakhan hat that was a gift from President Ayub Khan, Jackie confessed that "I asked to try his, and it was just right, so he gave it to me." Dressed in a soft rose-and-white checkered silk suit, she gamely pets a decorated sheep, which was a gift from Pakistani chieftains.

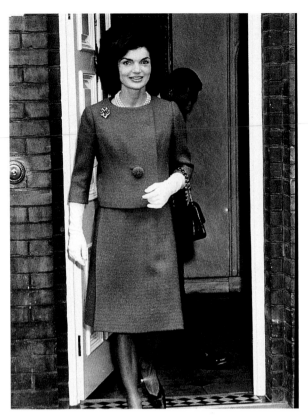

Jackie wore a claret-colored wool suit for a private lunch with Queen Elizabeth during a stopover in London, en route back to the States. When asked, inevitably, about fashion, she diplomatically replied, "I thought the Queen's clothes were lovely and she was most gracious."

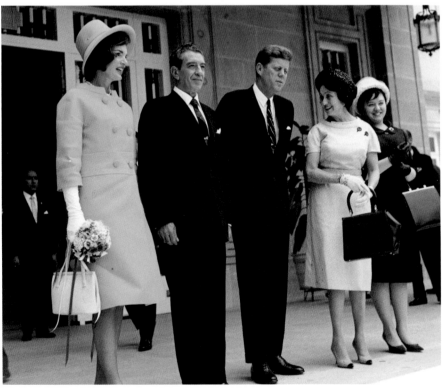

Jackie was sensitive about being photographed in the same outfit, so she made an arrangement with Oleg Cassini to select her clothes for the Mexican trip from his own collection, and she would return them to him. She asked for this pale green gazar dress and coat with a matching hat in a flat, shiny straw.

This white dress, with its black buttons and black leather belt, draws its inspiration from the military. It made its first appearance in Mexico but did additional duty back in Washington.

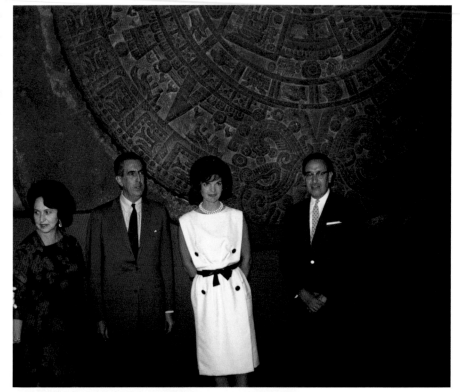

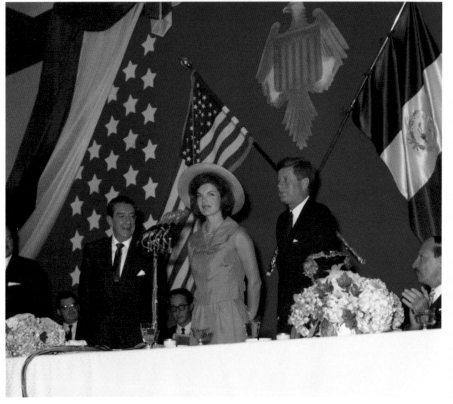

A great part of Jackie's international appeal was her linguistic ability; she, unlike the President, was able to speak French, Italian, and Spanish. In preparation for their trip to Mexico in June 1962, Jackie used Spanish Linguaphone records to cram for the trip and practiced with her maid, Provi. She wears a hot-pink sleeveless dress with a wide-brimmed hat to address a luncheon.

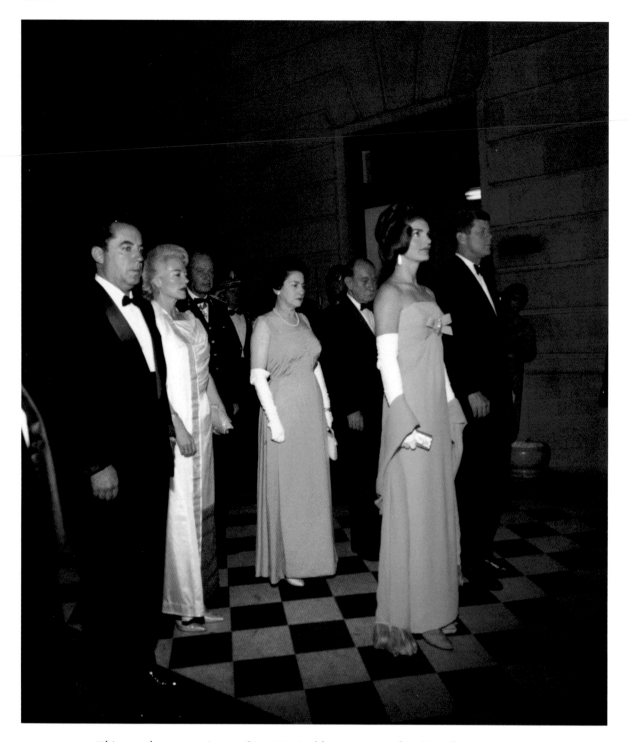

This strapless gown, in a striking Nattier blue, was one of Jackie's favorite evening gowns, one that she continued to wear in her post–White House years. She wore her starburst pin on the bodice of the dress, which came with a long matching fringed stole.

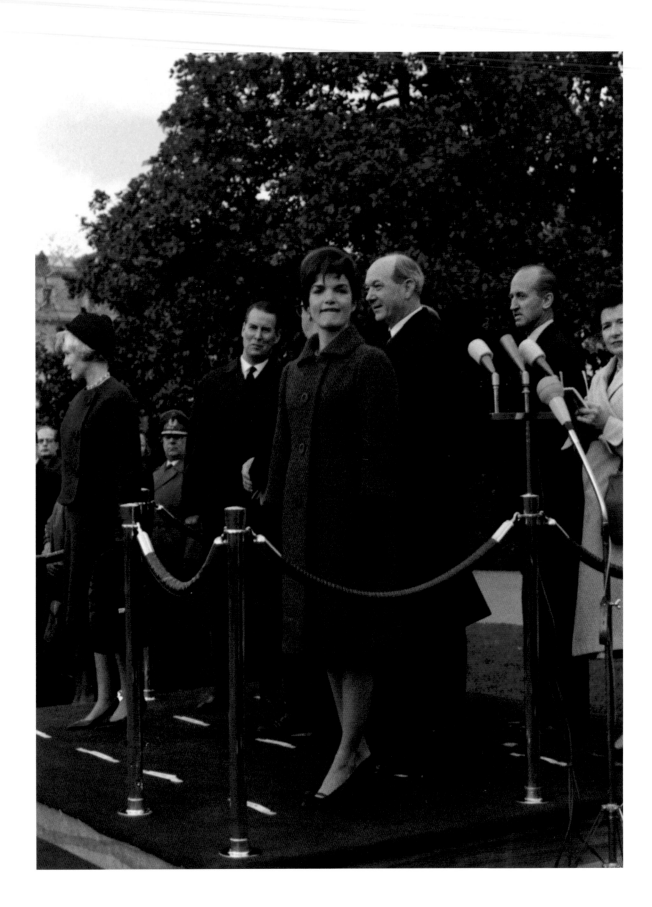

· chapter five ·

Day Clothes

Now, would you put your brilliant mind to work for day. . . .
What I need are dresses and coats for daytime, dresses suitable
to wear to lunch. . . . I don't know if you design coats, but I now
see that will be one of my biggest problems, as every time one
goes out of the house, one is photographed in the same coat.

— Jacqueline Kennedy to Oleg Cassini, 1960

Nine days after the 1960 election, Jackie wrote to Oleg Cassini, outlining her wardrobe needs. Years later he recalled that "there was great pressure to provide clothes quickly. She didn't have anything to wear, literally, for the first week or so in the White House, and she couldn't go out. We made a special workshop just for her. We were always rushing to get something done."

Cassini had visited her in Georgetown University Hospital the week after John F. Kennedy Jr.'s birth. He remembers that she was "smiling and perky . . . she was a very strong girl." He presented his plan for designing her entire wardrobe, and she understood that his Hollywood experience was well suited to the task at hand, creating a visual interpretation of the new kind of President's wife that she intended to be. After a potential ghastly mishap—the inaugural ceremony coat was made with a thin silk lining, and Cassini had to rush around Washington at the last minute to have a warmer one installed—he quickly earned her trust, and her orders came flying in.

"Now for spring," she wrote in February 1961. "Let's get one beautiful wool suit—bright color, 1 with reversible jacket, a daytime tailored coat, wool, but not too heavy—to wear over anything—maybe pale yellow fleece or gray? Three daytime linen or shantung [dresses:] one with a jacket, one with nothing, one with a coat? Or maybe two with jackets? Or three dressier afternoon dresses [:] 2 pc shantung with straw hat, white with black polka dots, another not too décolleté, 1 flowered chiffon for garden party or short evening. 1 lace dress with matching coat, another fabulous long evening dress. What will I wear over the straw one and ribbed organdie when I go out—stole? Nothing? Send me sketches, then I'll be set till fall, except for a couple of Summer things to wear at the cape."

Before Cassini cut into any of these rich fabrics, he would have the First Lady's complete instructions. First he would send her fully rendered sketches. Jackie would study them carefully and make subtle changes—a higher neckline, a rounded shoulder. It wasn't always smooth sailing. "She always knew what she wanted," Cassini remembered. "I propose and she disposes" was his mantra. He also sent her fabric swatches in the colors in which he thought each dress would look best on her.

And the look was very simple—no complicated cuts, no fussy trims, very few prints. The dressmaker suits had her favorite three-quarter-length sleeves and boxy jackets and straight or slightly gathered skirts.

Oleg Cassini created more than a hundred outfits for her that first year in the White House. These dresses, suits, and coats formed the basis of the First Lady's working wardrobe. These clothes were rarely eye-catching, but then, they weren't meant to be anything more than eminently suitable for the occasion. In this endeavor, they triumphed.

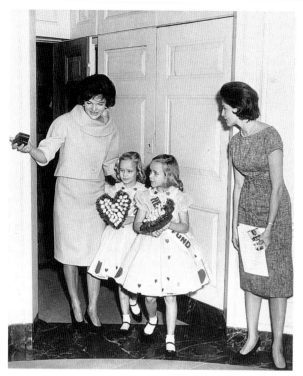

One of the new First Lady's earliest engagements was meeting the Heart Fund Twins on February 1, 1961. Her suit was a subtle pink shade, described by Cassini as "Nattier inspired." Rarely again did she make this sort of public appearance.

The First Lady wore an embossed damask suit in deep rose for the diplomatic reception on February 8.

"Jackie hated any press coverage of her wardrobe," confided her social secretary, Tish Baldrige. "By using Oleg and saying he made all her clothes, Jackie could be sure no one would ever say how much was actually made by him. He was a great friend of the family and helped her in many ways. Don't forget, she was only thirty-one years old."

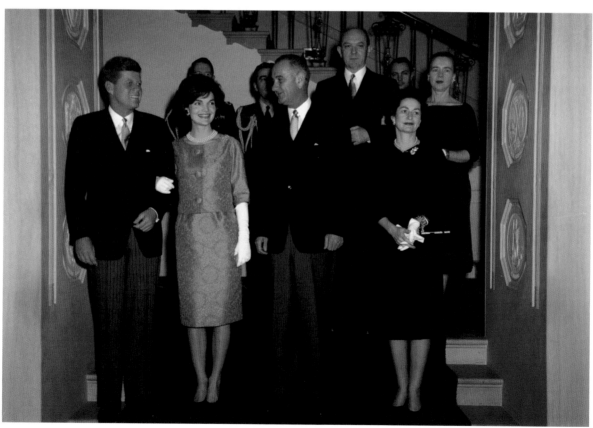

This white wool dress, with its self-tie decoration at the neck, was worn for Jackie's official White House photographs. Here she leaves a luncheon at the home of Mrs. Woodrow Wilson, widow of the former President.

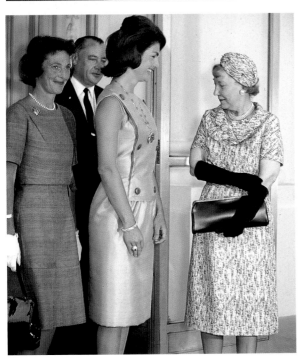

President Kennedy invited Mamie Eisenhower to serve with Jackie as co-chairman of the board of the proposed National Cultural Center. They posed for photographs on the North Portico of the White House; Mamie, noted for her exuberantly fifties fashion sense, casts a disapproving eye over Jackie's simple, pared-down look.

This suit was made of a sumptuous silk peau de soie, with silver thread embroidered in a medallion pattern. Today it is in the collection of the Museum of American History at the Smithsonian, but Jackie wears it here to attend the New York City Ballet with Adlai Stevenson.

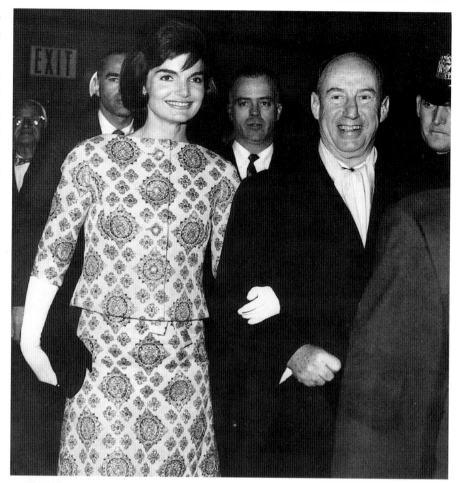

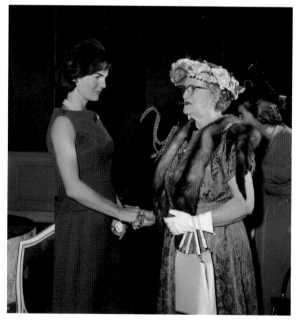

Rarely is the breath of fresh air that Jacqueline Kennedy brought to the White House illustrated better than in this photograph of the thirty-one-year-old First Lady greeting this fabulous example of "dowager chic" at a reception for wives of prominent newspaper editors.

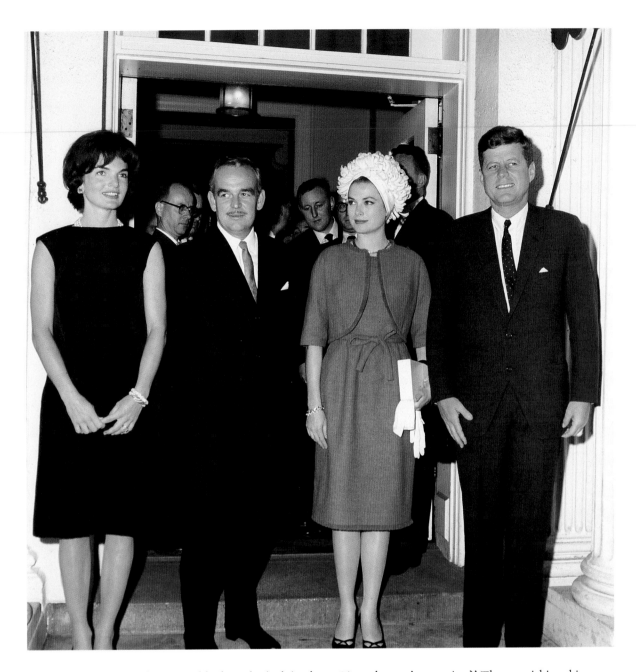

"At luncheon he turned to me suddenly and asked: 'Is that a Givenchy you're wearing?' The astonishing thing was that that day, *that* particular dress just happened to be one.

"I said, 'How clever of you, Mr. President! However did you know?'

"'Oh,' he replied, 'I'm getting pretty good at it—now that fashion is becoming more important than politics and the press is paying more attention to Jackie's clothes than to my speeches.'

"This was just around the time the Americans were becoming aware that in Mrs. Kennedy there was a genuine leader of women's fashions in the White House again."

—Princess Grace, June 1965

Jackie's simple midnight-blue silk sheath stands out in stark contrast to the colorful ensembles of the wives of foreign ambassadors whom she had invited for tea.

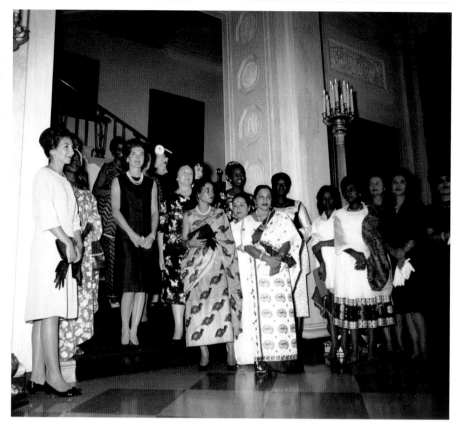

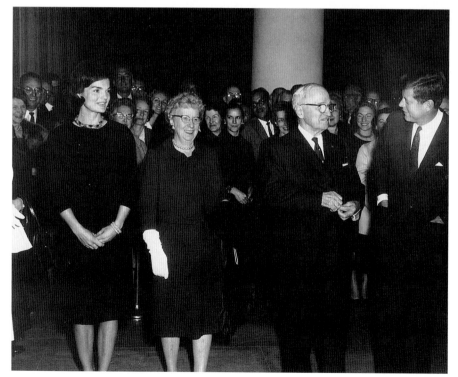

The Kennedys welcomed Harry and Bess Truman and their daughter, Margaret, back to the White House for an overnight visit that included a black-tie dinner in the former President's honor.

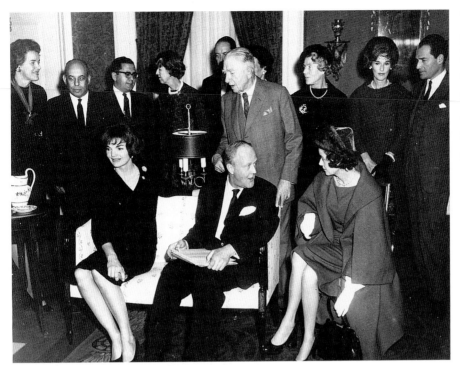

The First Lady gave a tea party for the members of her grandly titled Special Committee on Paintings for the White House. Standing second from the right is another American style icon, Barbara "Babe" Paley.

A simple plaid dress and pearls worn while greeting a donor to her cherished White House restoration project.

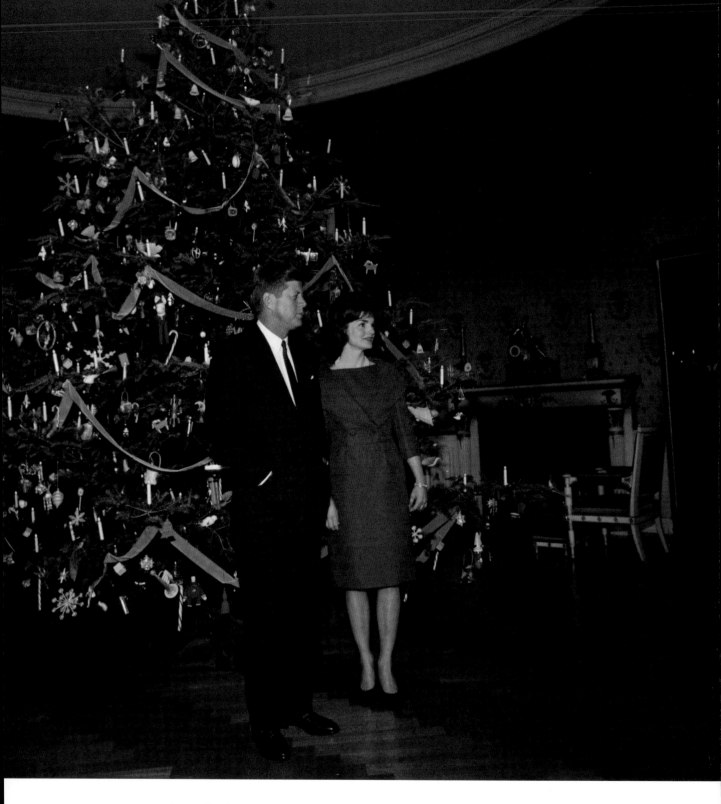

For the staff Christmas party in 1961, Jackie wore a cherry-red brocade suit with a
wide shawl collar as its main feature.

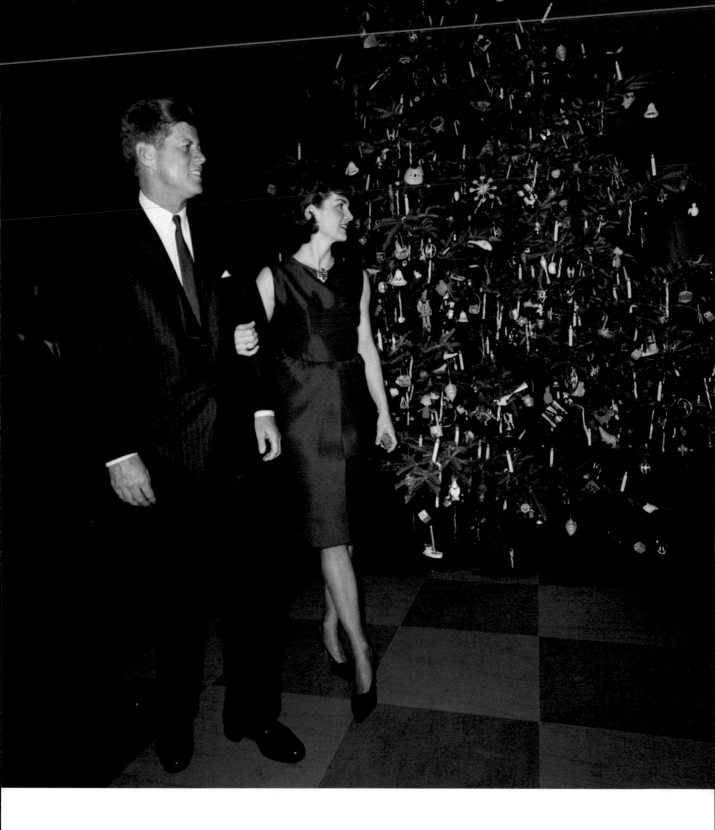

Jackie's 1962 Christmas party dress was made of cerise satin and was sleeveless.

This Oleg Cassini sketch for a day dress featured a diagonal closing, a loosely tied belt, and a slightly flared skirt with box pleats. The matching jacket was loosely fitted and had notched lapels. It was suggested in pale chartreuse lightweight wool.

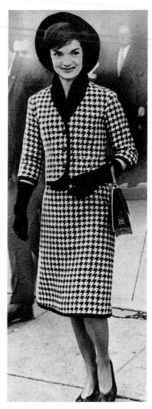

This black-and-white houndstooth check suit had been the mainstay of her primary campaign wardrobe in the spring of 1960 and was still being worn two years later when Jackie returned from Palm Beach after the New Year holiday.

This brown wool suit was one of the early Cassini efforts and featured many details that would make regular appearances in the First Lady's wardrobe—a "greatcoat" collar, big contrasting buttons, and a softly gathered skirt.

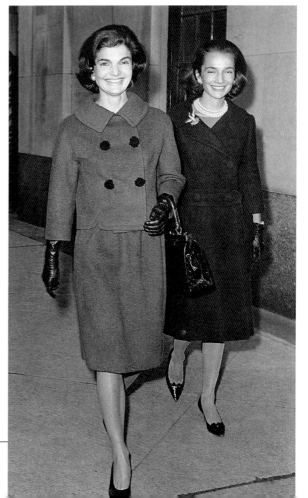

Reporters in New York City commented on this casual coat and noted its "off-the-neck collar and large pockets." Jackie is seen here leaving Chez Ninon, the New York shop where she purchased many of her French-designed clothes.

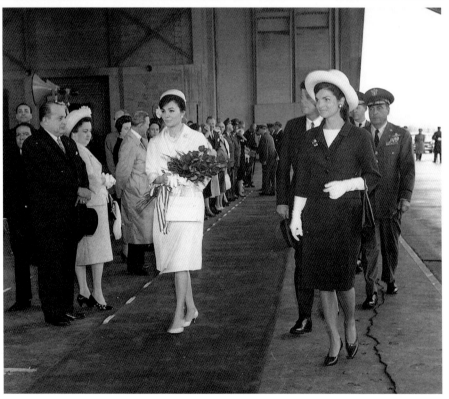

American fashion pride was put to the test during the state visit of the shah and Empress of Iran. The young Empress was highly regarded for her fashion sense. Jacqueline Kennedy passed the test with flying colors in this navy suit with a wide-brimmed white straw Givenchy hat that framed her face with light, giving her a subtle advantage over the Empress.

"Je te baptiste *Lafayette*," proclaimed the First Lady as she swung the traditional bottle of champagne to launch the American nuclear-powered submarine. She wore a pale green coat and hat, which, perhaps as a witty acknowledgment to her seafaring surroundings, was worn at a jaunty angle.

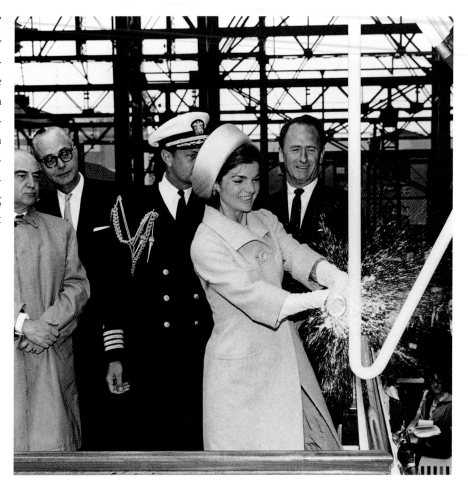

This polka-dot dress was "sleek and chic" with its nipped waist, contrasting cummerbund belt, and side seam pockets.

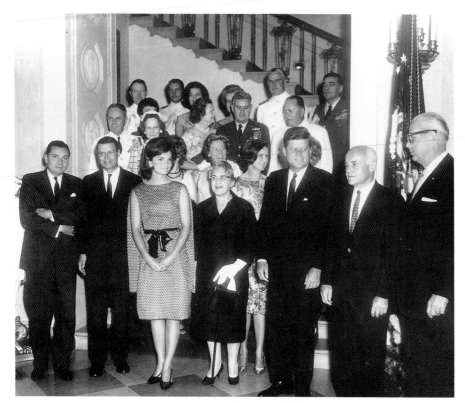

Polka dots turned up again in a dress worn to the annual military reception. The cape effect is another one of her fashion experiments, one not given a repeat performance.

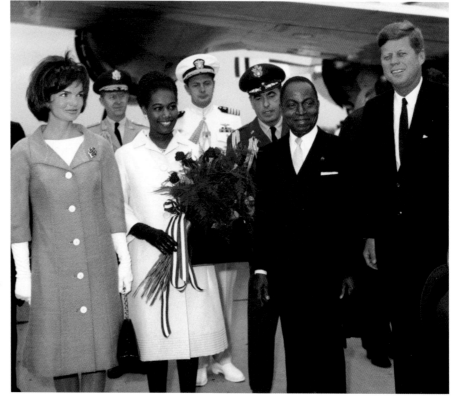

When President Houphouët-Boigny of the Ivory Coast and his lovely wife arrived in Washington, the Kennedys were there to greet them. Jackie wore a lightweight wool coat of black-and-white check, adorned with a sapphire-and-diamond pin. No hat, but a black bow headband.

Ayub Khan, the President of Pakistan, enjoyed a close relationship with the First Lady. When he returned to the United State in 1962, the Kennedys entertained him at Hammersmith Farm, the site of their 1953 wedding reception. Her mustard-colored wool suit featured a wing collar and the large buttons typical of the Cassini look.

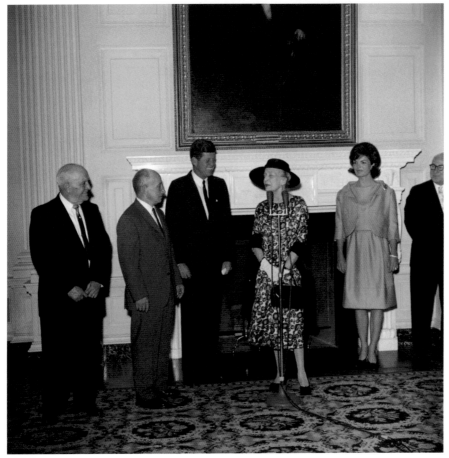

Alice Roosevelt Longworth came back to the White House for the dedication of a replica of the State Dining Room's marble mantelpiece. Her father, Teddy Roosevelt, insisted that architects McKim, Mead and White include an American Buffalo, rather than an African lion, in the mantel's decorations. The color and fabric of Jackie's green suit are similar to the Givenchy that Princess Grace had worn to lunch the year before.

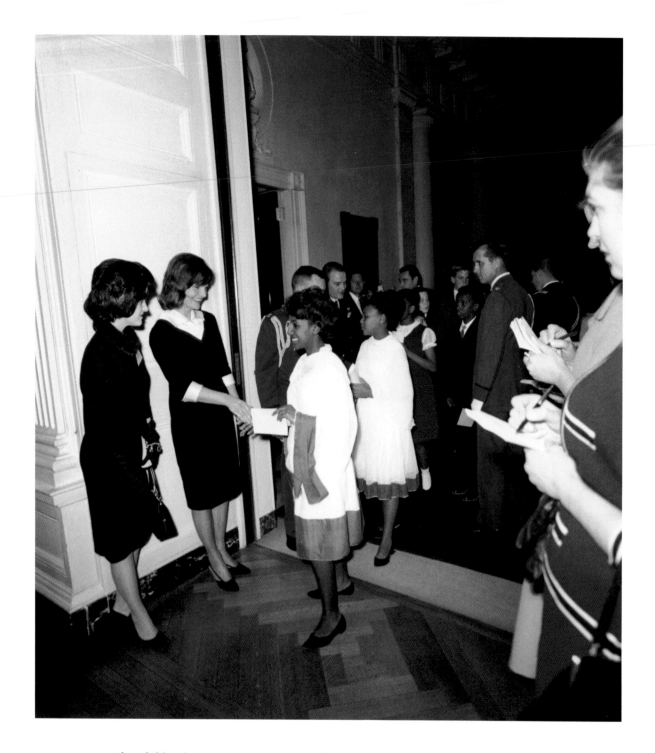

The Children's Concerts were a series of musical programs designed to whet young people's appetite for music. Mrs. Kennedy greets her young guests with the help of Luci Baines Johnson, the Vice President's youngest daughter. Her dress was a trompe l'oeil affair in black velvet and white satin.

Wearing a brown suit and a mink beret, Jacqueline Kennedy distributes lollipops during a Christmastime visit to Junior Village, a haven for homeless and underprivileged children.

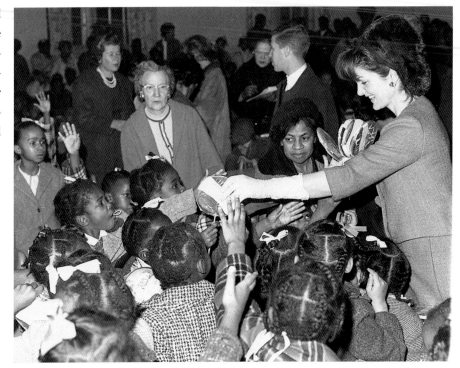

Though close, the First Lady and her sister did engage in a fashion rivalry. "Oh, Jackie is the one in her mink coat," Lee Radziwell confided to Jackie's secretary when the sisters attended JFK's State of the Union Address.

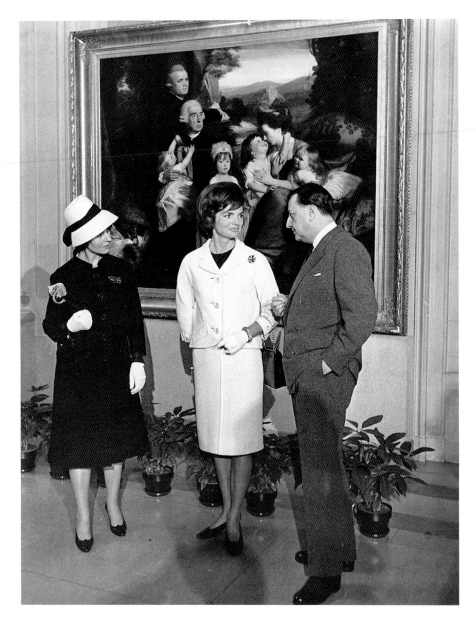

A John Singleton Copley portrait forms the backdrop for the First Lady, who's escorting André Malraux and his wife through the National Gallery of Art. Her simple white suit is accessorized with her sapphire-and-diamond pin and a Cartier panther bracelet, similar to one owned by the Duchess of Windsor.

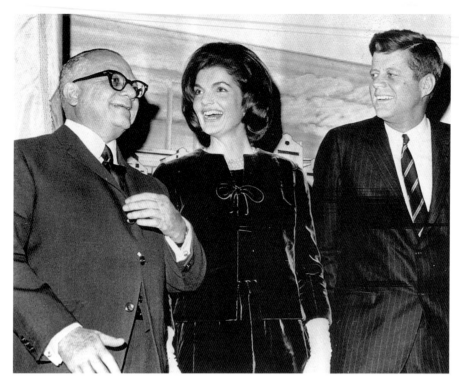

Jackie asked Cassini's help for "cocktail dresses suitable for afternoon receptions and receiving lines—in other words, fairly covered up. Also, one or two silk coats to wear over them when I go out in the late afternoon." He made this suit for her twice, in black silk velvet, seen here, and also in yellow linen for the trip to Mexico.

When Jackie was warned by a friend, prior to moving into the White House, that she would have to compromise some of her independence, her response was coy: "Oh, I will. I'll wear hats." But as she later wrote to Marita O'Connor of Bergdorf Goodman: "Here goes—an order for a million hats. . . . It was so pleasant when I didn't have to wear hats! They will pauperize me & I still feel absurd in them." Here she looks anything but absurd in a fetching hat of shiny black straw that she wore to welcome Morocco's King Hassan II to Washington.

In September 1963, Jacqueline Kennedy returned to Washington for the first time since the death of her son Patrick six weeks earlier. Her fleecy light-gray wool coat was one of the first that Cassini designed for her, always mindful that her comings and goings would be photographed.

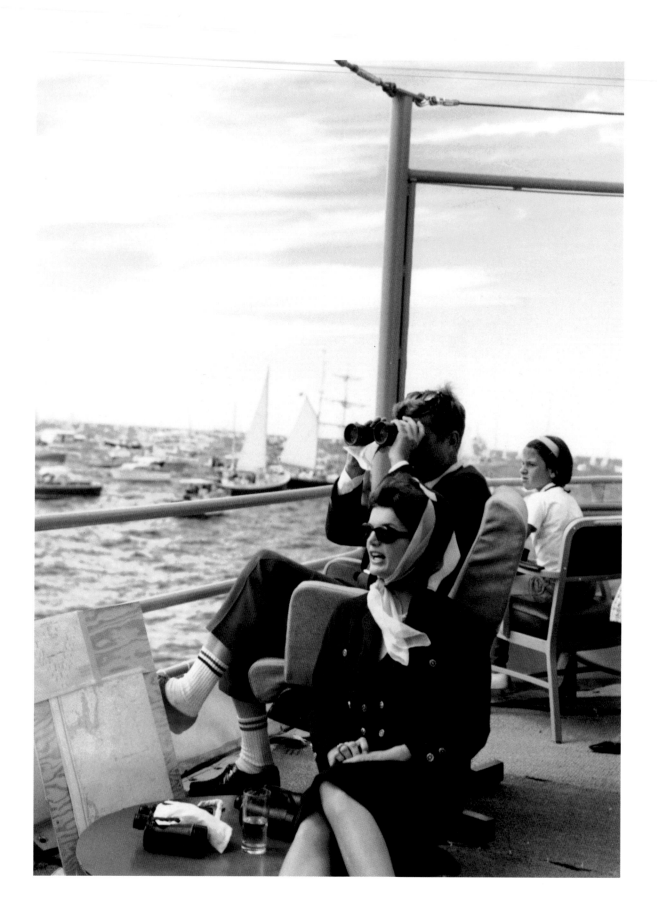

• chapter six •

Private Life:
The "Off-Duty" Wardrobe

Mrs. Kennedy always maintained her allegiance to sportswear
and to the modern ideal of American sportswear. . . . She trans-
lated this ideal into her wardrobe for day and evening, reconcil-
ing the elegant simplicity of Givenchy and the reduced
silhouettes of the 1960s with the principles she well understood
from sportswear.

—*Richard Martin,*
Metropolitan Museum of Art Costume Institute

J. Bernard West, the chief usher of the White House, once said, "I can't remember [Mrs. Kennedy] ever wearing a dress in the White House, unless she had company." On her first day in residence, she asked West to introduce her to the Executive Mansion staff, and the butlers, maids, cooks, and ushers were amazed to see the new mistress of the house sitting casually on a desk in jodhpurs and an open white shirt. That casual sense was key to Jackie's off-duty uniform. Dressing in slacks and long-sleeved jersey turtleneck pullovers, she would stick to browns and grays during the winter, but in spring her choices would blossom—pinks, reds, yellows, and blues.

Her off-duty life was based at the White House, where the decoration of the family quarters created a sophisticated and luxurious counterpoint to the historical restoration of the state rooms. It fanned out to weekend retreats at Glen Ora and later Atoka, both estates in Virginia's hunt country. There was New York City for short trips to attend the theater and ballet, scout art galleries, and shop. There was Hyannis Port for the summer, Newport in September, and private visits to Greece, London, and Ravello, Italy.

As First Lady, Jackie stopped her practice of selling her unwanted clothes through Encore, the New York City resale shop. Her formal clothes were stored in cedar-lined storage closets in the White House. She would send some of her informal clothes to her brother-in-law Stas Radziwell's relatives in Poland, using her secretary's name as a cover. With her Kennedy in-laws, she was less restrained. When Ethel gave her a blue robe as a gift, Jackie thanked her, saying that she never took it off, like the disheveled heroine in *Come Back Little Sheba*, who never changed out of her drab housecoat.

Her secretary ordered from a variety of upmarket stores and boutiques: Garfinckel's (for stockings), Bloomingdale's (Revlon lipsticks, Nearly Peach and Strawberry White Pale), Bergdorf Goodman, Bonwit Teller (for lingerie), Lord & Taylor, Gimbel's, and Elizabeth Arden for "pretty nightgowns—long, not too décolleté." All the shopping took a toll on the President's budget: "She's breaking my ass" was his frequent complaint. In the second quarter of 1961, when, admittedly, her clothing needs were high, records indicate that she spent more than fifteen thousand dollars on clothes in those three months, with a four-thousand-dollar bill to Givenchy alone. JFK would put his foot down, and for a while there would be economies, itemizing powder puffs from Julius Garfinckel at $1.13 each. But things would soon be back to normal, with Jackie's non-Cassini clothing expenditures for 1961 totaling forty thousand dollars. Her Vassar dormmate Charlotte Curtis would write in great detail about the cost of the First Lady's wardrobe—$3,900 worth of hats from Bergdorf Goodman and $8,000 for the Somali leopard coat. Cassini, whom Jackie counted on for his discretion, expressed fear that the press would "cut him up" if he stayed mum on the subject of her clothes. She told him to "just say one phrase over and over—'I'm so sorry, but with respect to Mrs. K's privacy, I'd rather not discuss her. I know you understand.' Then they'll think you are so chivalrous." He followed her advice and has never divulged the financial aspects of the Kennedy wardrobe.

The Kennedys used the Yellow Oval Room as their formal salon. It was the triumph of decorator Sister Parish's work in the White House.

Jackie's dressing room was a luxurious and ultra-feminine retreat, tucked away in the corner of the family quarters. It was decorated with French prints that she had acquired during her student days in Paris, a blue satin fainting couch for afternoon naps, and a leopard-skin throw.

Prominently featured on the mantel in Jackie's bedroom is a Greek alabaster head of a woman. This was one of her treasured possessions; it was included in her official White House portrait, and she left it in her will to her companion and friend Maurice Tempelsman.

The West Hall was the Kennedy family living room. There Jackie placed her Georgetown furniture and had the bookcases built to house her eclectic collection of books. The marble-topped bureau on the left was a gift from Charles de Gaulle. Note the children's books on the side table and the small vase filled with simple daisies.

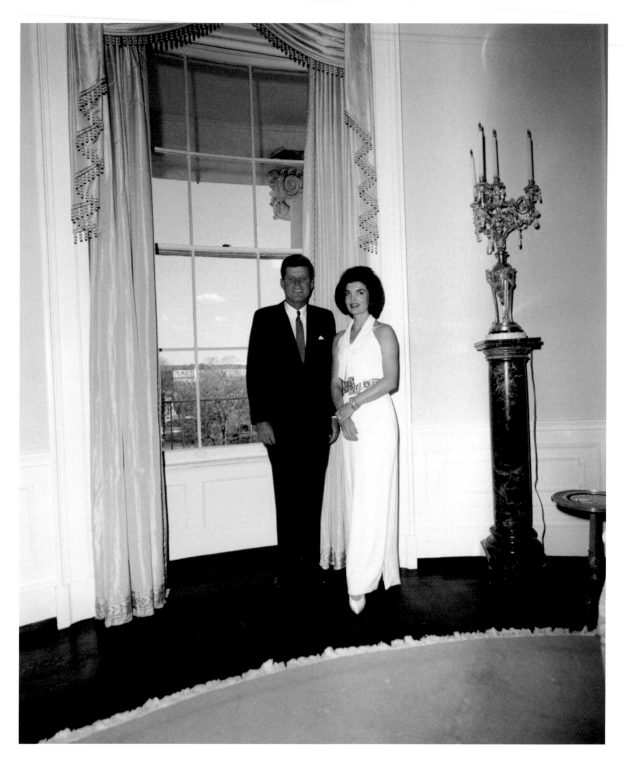

The magnificent gem-encrusted gold belt and bracelet were among the state gifts from the King of Morocco to the First Lady. Wearing a very sophisticated halter-top white silk outfit, Jackie models her new jewels in the Yellow Oval Room.

Caroline's fifth birthday was celebrated with a party in the family dining room in November 1962. Jackie, in a simple burnt orange silk sheath, carries in the cake.

When members of a Native American council came to call on the President, Jackie invited them into the residence to meet John-John. Her pink wool dress is typical of the simple dresses she wore when "off duty."

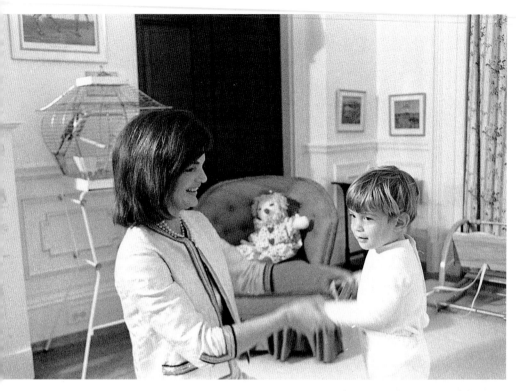

After taking some formal portraits, Jackie dances with her son in his White House bedroom. This suit was one of her favorites, made of white silk brocade with a black and gold trim around the jacket.

In line with her determination to create a normal childhood for Caroline and John, Jackie (seen here with Caroline, sister-in-law Jean Smith, and nephew Willie in the rear) led a trick-or-treat expedition to Georgetown on Halloween 1962.

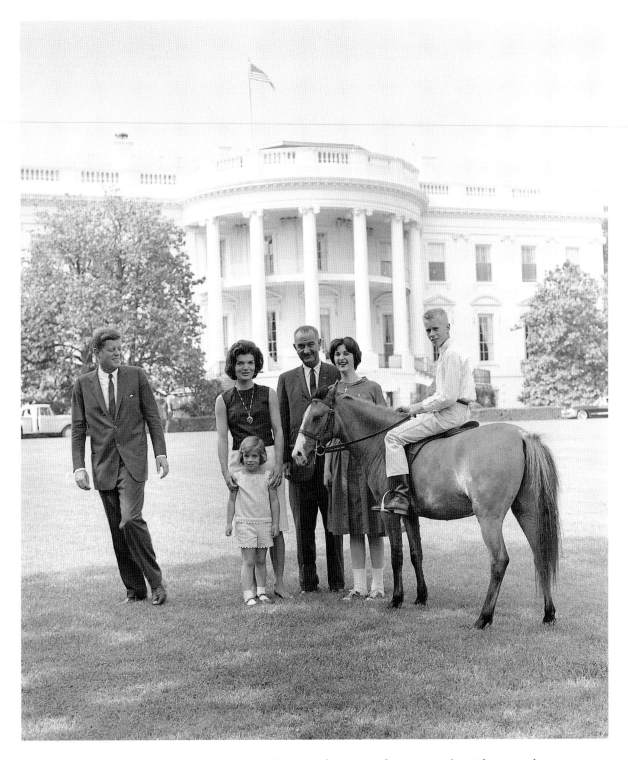

Caroline's pony, Macaroni, was almost as famous as she was. Lyndon Johnson and his daughter Lynda Bird visited one day when the First Family had brought Macaroni in from their country retreat, Glen Ora.

Lee Radziwell was a frequent visitor to the White House. The sisters, in matching coats, stand outside the Oval Office with the President's goddaughter, Christina, and Clipper, a German shepherd that was a gift to the First Lady from her father-in-law.

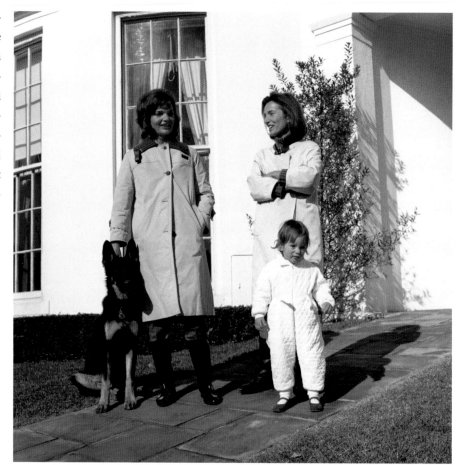

Tony Bradlee, wife of the then *Newsweek* Washington bureau chief Ben Bradlee, was one of Jackie's closest friends during the White House years. One April morning they sat at the great fountain on the South Lawn of the White House grounds as their children swam and played.

JFK leads a toast at a surprise forty-sixth birthday party that Jackie organized in the White House mess. Her black-and-white ottoman dress just begins to hint at her pregnancy.

Jackie wore the same outfit when Ben and Tony Bradlee came to dinner. The two couples sit in the family sitting room in the private apartments on the second floor of the White House. Foreign magazines *Femme* and *Stern* lie on the coffee table, and photographs of Jack Bouvier, Jackie's father, adorn the side tables.

During the summer of her pregnancy in 1963, Jackie favored a hot-pink shift dress and wore it time and time again, here at a White House recital for Caroline's dance class.

Art dealer Leo Castelli gave President Kennedy a bronze sculpture in June 1963. Jackie, again in the pink maternity shift, dropped by the Rose Garden to take a closer look at the piece of contemporary art. Their friend Bill Walton stands behind Mr. Castelli.

Haile Selassie, the Emperor of Ethiopia, arrived at the White House on the morning that Jackie was leaving for her recuperative trip to Greece aboard Aristotle Onassis's yacht. She took part in the welcoming ceremonies, and when he presented her with a leopard-skin coat, she—despite the sweltering heat—wore it in the Rose Garden as a gesture of respect and appreciation.

Caroline practices her ballet on Christmas morning 1962 as her mother and baby brother watch appreciatively. One of Jackie's favorite gifts were these raspberry pink silk lounging pajamas from Princess Irene Medici of Rome. Lee Radziwell received a similar pair, and in her thank you note Jackie wrote that they wore them like uniforms and that the house looked like a convent.

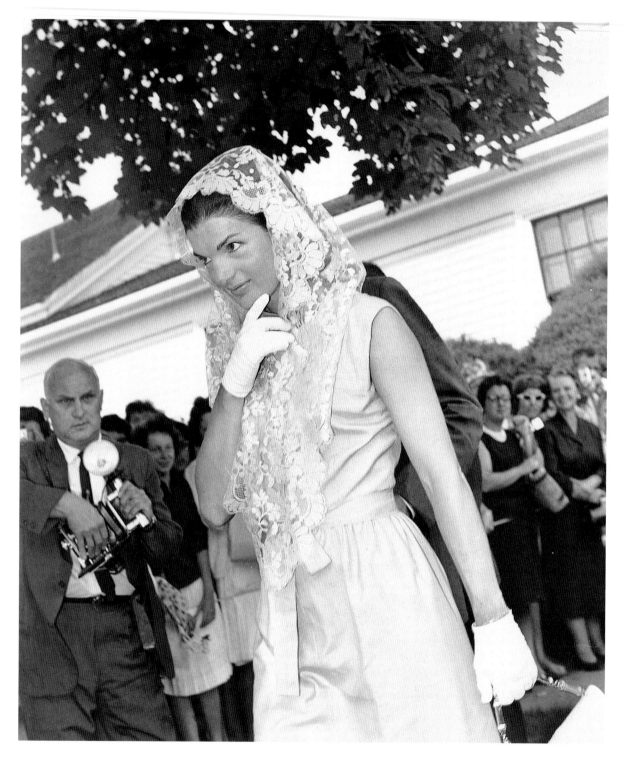

A simple sleeveless dress, a lace mantilla covering the head, and wrist-length gloves revolutionized the churchgoing wardrobe of American Catholic women in the early 1960s.

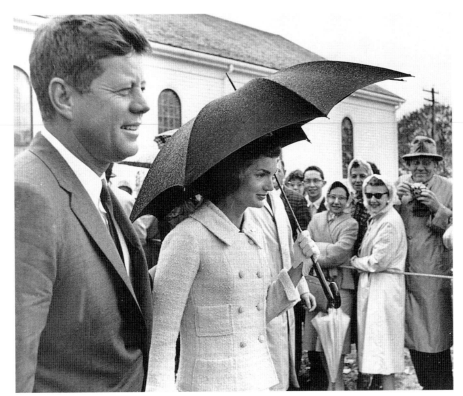

On a rainy Sunday morning in Hyannis, Jackie wore a tailored wool suit to Mass at St. Francis Xavier Church, where the Kennedy family has worshiped for three-quarters of a century.

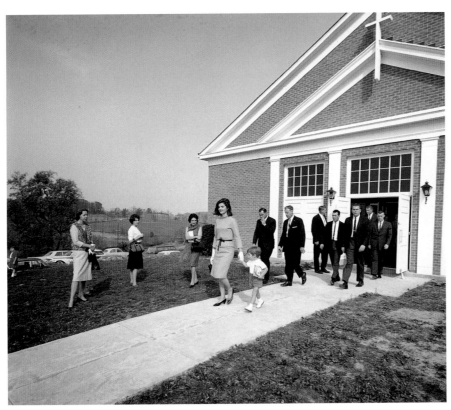

Reporter Helen Thomas covers the "news" of Jackie and her young son attending Mass in Middleburg, Virginia, in the spring of 1963.

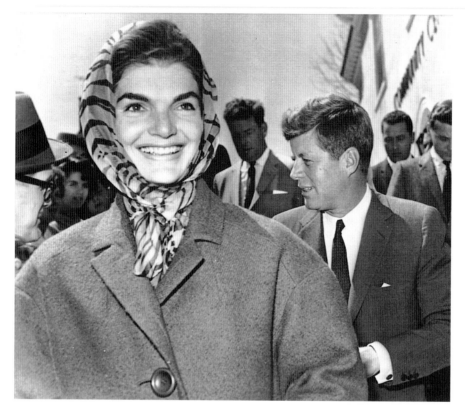

A "Jackie look" that would become one of her best known—the colorful scarf wrapped tightly around her head.

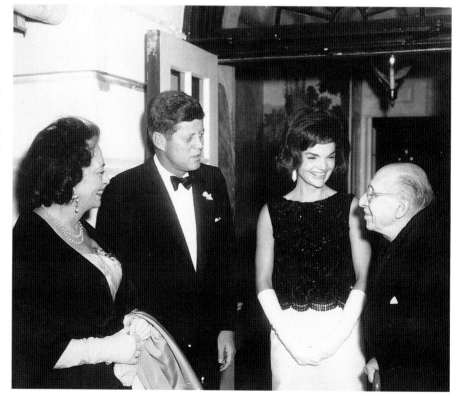

"One of the few nice things about being here," Jackie once said, "is we can get to meet everyone we've ever wanted to meet." In January 1962 she gave a dinner party for twelve in honor of Igor Stravinsky. When guest Leonard Bernstein kissed Stravinsky on both cheeks in greeting, JFK asked him, "Hey, what about me?" Jackie's jet-beaded camisole top is hemmed with swag fringe.

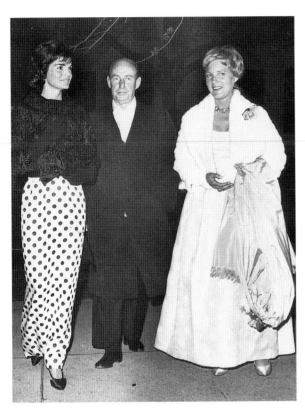

Jackie's private evenings out in Washington included attending the opera with Adlai Stevenson and the daughter of West German Chancellor Adenauer. She wore a striking polka-dot gown with a short fur jacket.

Jackie spent a week in March 1961 in New York City with her sister, Lee. They stayed at the Kennedys' apartment at the Carlyle Hotel and spent the week attending the ballet, visiting art galleries, and having fittings for Jackie's Easter and spring wardrobe.

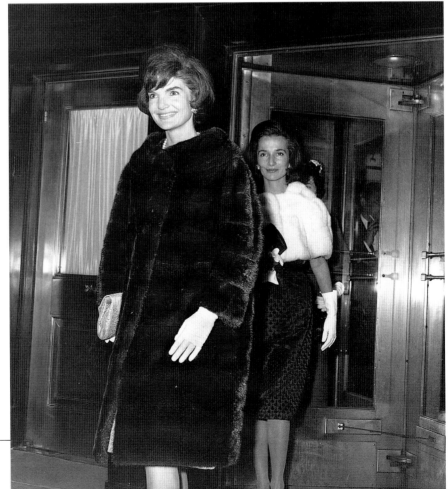

Gore Vidal recalls that "after a small dinner at the White House in 1961, Jackie dragged me and Jack to a horse show where [she said,] 'Jack will only have to stay for a few minutes.' We were there for an hour while Jack, seething, and I gossiped behind her back." Jackie presented the President's Cup to the winner, wearing a black velvet suit with white satin piping highlighting the jacket and a strawberry pin rendered in rubies and diamonds that the President had given her for Christmas 1960.

Jackie saved a rare smile of undiluted pleasure for a visit by Pakistani President Ayub Khan to Glen Ora, where Jackie housed Sadar, the magnificent gelding that Khan had given her as a gift during her visit to Pakistan. Her riding clothes were ordered from Gordon's, a British tailor specializing in hunting clothes, and the equestrian wardrobe included a navy gabardine coat with double vents, a tan silk coat, Bombay jodhpurs, and breeches in canary yellow and dark brown.

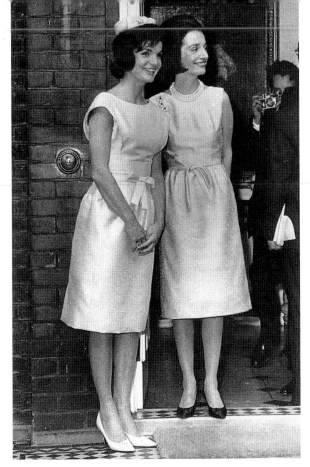

The centerpiece of the 1961 trip to London was the christening of Jackie's niece (and JFK's goddaughter) Anna Christina Radziwell. Jackie wore an oyster-white silk shantung dress with a small flat hat and matching coat. She and Lee wait for the crème de la crème of British society to arrive at the party celebrating the happy event.

During a summer trip to Ravello, Italy, Jackie wore this colorful shift while helping Caroline and niece Tina Radziwell onto a carnival ride.

In a pea-green one-piece bathing suit, Jackie poses with Caroline and nephew Anthony Radziwell and other members of her party in Ravello.

Isn't it nice to know that Jackie indulged in an ice-cream cone now and then?

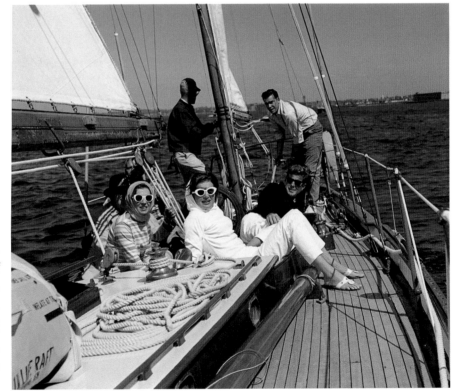

Sailing in Narragansett Bay, off the coast of Newport, with her mother, stepfather, and husband, Jackie is a crisp and cool portrait in white, including those fabulous sunglasses.

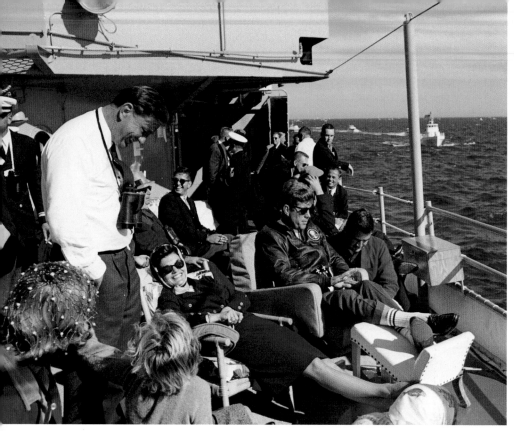

A perfectly relaxed Jackie sits amid the party watching the second America's Cup race in Newport, September 1962. Her navy blue suit, white and navy scarf, and dark glasses are the perfect outfit for this semi-official, semi-private event.

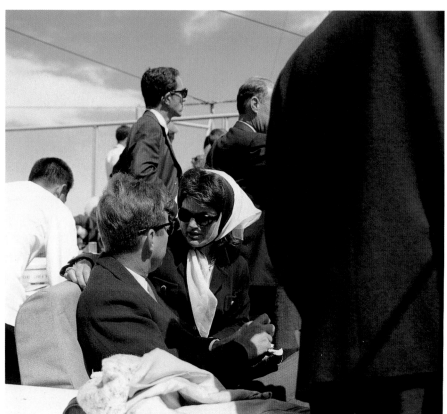

They had this remarkable ability, despite being the most famous couple in the world, to create pockets of intimacy whatever their surroundings.

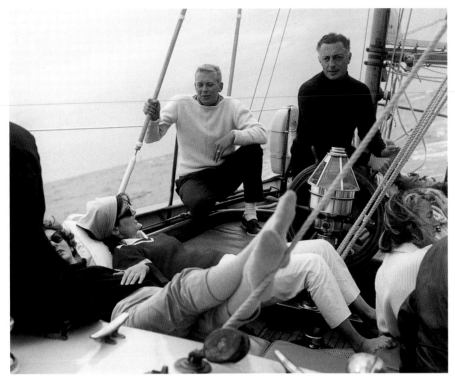

Sailing on the *Manitou* with Italian industrialist Gianni Angelli and his wife, Marella, Jackie chats with Lieutenant Reid, the boat's navy skipper. These September days sailing in Newport offered her complete relaxation, and her casual garb—a cotton sweater, white slacks, and a simple kerchief protecting her hair—perfectly illustrates her relaxed attitude.

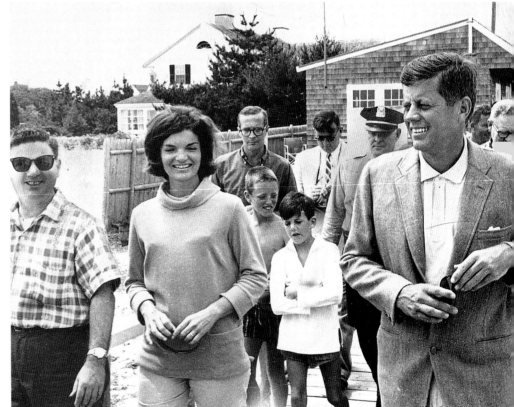

They could stroll around Hyannis Port in the most casual of clothes: slacks and a simple cowl-neck top for her, a sports jacket and informal shirt for him.

With Jack at the wheel, Jackie, Chuck Spalding, and Stas Radziwell leave the Kennedy compound for the President's rented house on nearby Squaw Island.

Joe Kennedy's birthday was celebrated in Hyannis Port on September 7, 1963. Barely a month after her baby Patrick's death, Jackie sits between her two favorite members of her husband's family, Joe and Bobby.

Part of a Kennedy family gag for Joe's birthday celebrations included this blowup of
Jackie and Lee wearing white coats, taken from the rear.

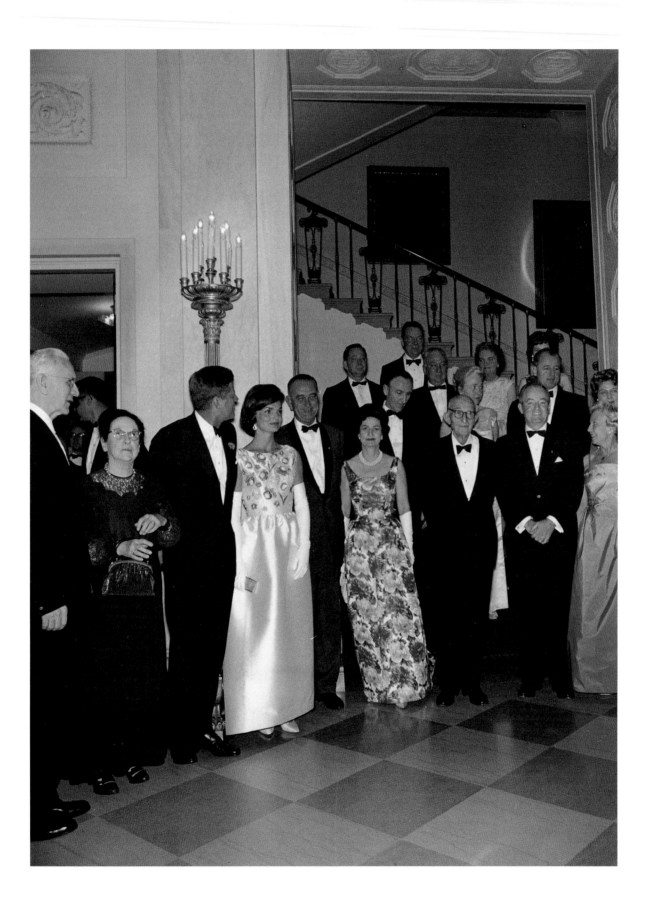

French Designers:
Haute Couture in the
Maison Blanche

*Jackie was trying hard to keep an American label on her clothes,
but she was not above checking on what Balenciaga and
Givenchy and others were doing and drawing.*

—Mary Gallagher,
My Life with Jacqueline Kennedy

I don't want to seem to be buying too much.... There just may be a few things we won't tell them about! But if I look impeccable the next four years, everyone will know it's you." With those words to Oleg Cassini, Jacqueline Kennedy neatly solved one of her biggest fashion problems, namely, how to continue wearing French clothes when it was politically expedient for her to patronize only American designers. It was a cat-and-mouse game played across four countries on two continents.

The First Lady had a network of friends and fashion professionals, her "scouts," continually on the lookout for gowns or fabrics in the various collections that they knew Jackie would like. Among these clothing scouts were Letizia Mowinckel in Paris and Princess Irene Galitzine in Rome. She wrote to Mowinckel: "What I really appreciate most of all is you letting me know before Lee about the treasures. Please always do that—now that she knows you are my 'scout,' she is slipping in there before me. So this fall, do let me know about the prettiest things first."

Jackie would use the scouts to order different items for her without letting any of the couturiers in Paris and London know whom they were for. Sometimes she would use a fabric one designer had in his collection and order something to be made for her by another designer.

She had been a longtime private client in Paris, as early as 1952, when she attended the opening of Hubert de Givenchy's salon. But Balenciaga, Chanel, Grès, and Cardin all benefited from her custom. Each house had a well-shaped Jacqueline Kennedy dummy, and she was known to order not one or two pieces but seven at a time, often from sketches sent to her in Washington.

But by appointing Oleg Cassini as her official designer and by stating that she would wear only his clothes (coupled with his own discretion), it became impossible to know just what came from where and who, if not Cassini, designed which dress. And for the most part, it worked brilliantly. People were so dazzled by Jacqueline Kennedy that the provenance of her clothes became a moot point.

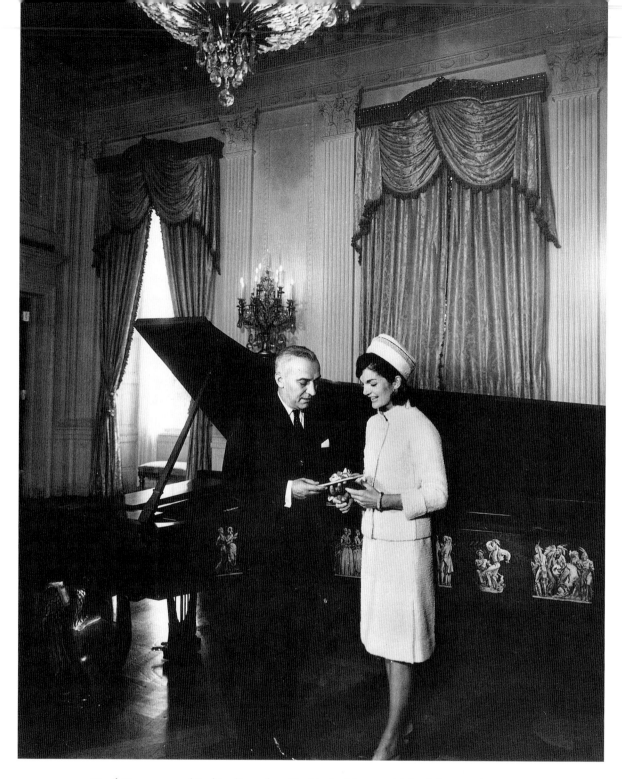

Cecil Beaton noted in his diary that "Jackie had been criticized for wearing Paris dresses, but she just laughed and seemed to have no fear of criticism. She enjoys so many aspects of her job, and takes for granted the more onerous onslaughts of the press."

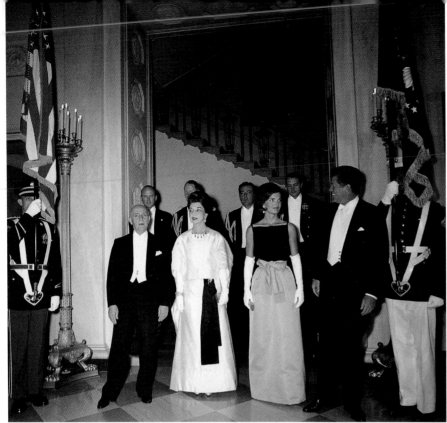

Tish Baldrige on JFK: "He loved the orange skirt and the black velvet top, a French evening gown that she had." The evening was a state dinner for the President of Peru and his wife in September 1961, and the dress was a French import via the New York couture shop Chez Ninon.

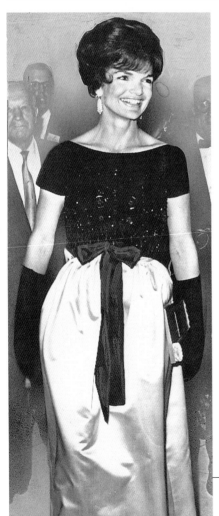

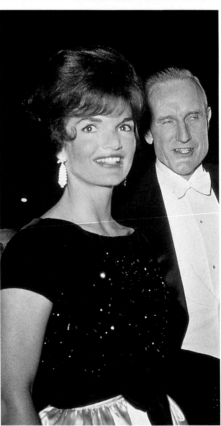

At the opening of Lincoln Center in New York, Mrs. Kennedy made a grand appearance in a black beaded velvet sweater top, over an apricot-pink bell-shaped satin skirt from Nina Ricci, Paris, again via Chez Ninon.

This classic Chanel suit, in black wool with a white satin collar and cuffs and matching satin blouse, was photographed for *Vogue* in 1956. Jackie poses during a White House reception for the American National Theatre and Academy. On her right is Peggy Wood, president of ANTA and future Oscar nominee for *The Sound of Music* (she played the Mother Abbess).

"Jackie loved Chanel suits," remembered Mary Gallagher in her 1969 memoir. "She liked their comfort and style and often made her own choice of piping or braid edging to be used. I recall she wore an off-white Chanel suit with black braid edging when Empress Farah Diba and she walked around the White House grounds during the state visit of the Shah of Iran in the spring of 1962."

This suit was one of the First Lady's favorites and was worn often, here at the wedding of Protocol Chief Angier Biddle Duke and Robin Chandler in May 1962. Standing between her and JFK is the wife of Senator Claiborne Pell of Rhode Island.

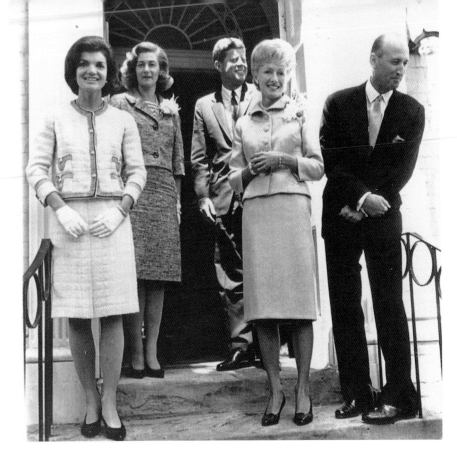

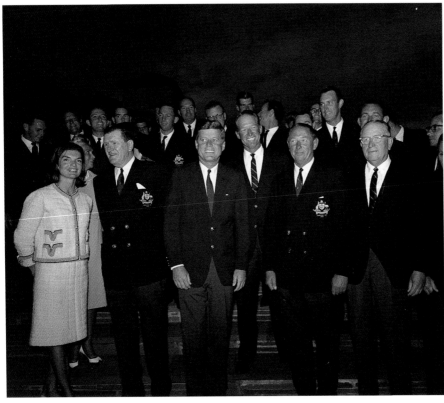

And again, later that year, in Newport, where the Kennedys celebrated the America's Cup race.

The White House, in advance of the state visit to Paris, released these two Givenchy sketches. They were identified as being designed by Chez Ninon. In reality, the tony New York shop acted as a go-between for the French designer and the First Lady.

Yvonne de Gaulle escorts Jacqueline Kennedy during the arrival ceremonies at Orly Airport outside of Paris. Jackie is wearing the pale blue wool coat from Givenchy.

Jackie wore Givenchy's navy silk suit in Paris and Vienna. The couturier told biographer Sarah Bradford that he had been asked "to prepare a complete wardrobe for this special trip. And this had to be kept a secret. . . . Only at the last minute, that means one hour before Mrs. Kennedy left for Versailles, were we allowed to say that Mrs. Kennedy's wardrobe was made by us." It was "a compliment to her French hosts" to wear French-designed clothes.

Before going on to India and Pakistan, Mrs. Kennedy made a brief stopover in Rome, where she was welcomed by Italian President Giovanni Gronchi. *Women's Wear Daily* reported that her charcoal dress with its wide leather belt was by Dior. It also said that she enjoyed a private showing of the Fabiani collection and purchased two or three evening gowns.

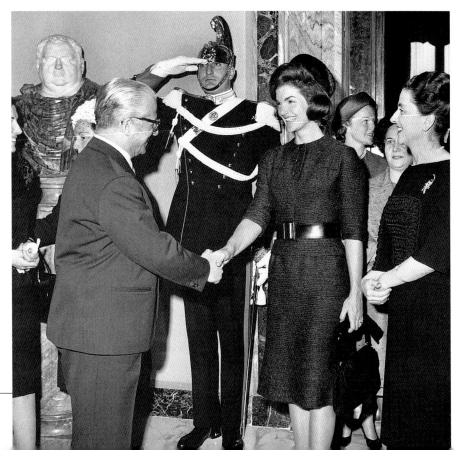

The eagle-eyed *Women's Wear Daily*, which assigned a Washington-based correspondent to cover the First Lady's wardrobe exclusively, identified this white coat with its six black crystal buttons as a Givenchy, again brought through Chez Ninon.

For a White House ceremony granting American citizenship to Winston Churchill, Jackie mixes her French—wearing her Chanel crepe blouse with the navy Givenchy suit.

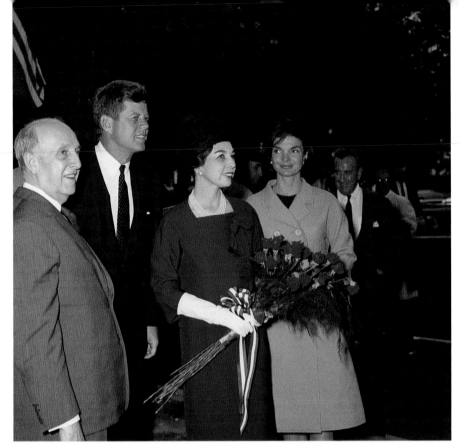

The writer Norman Mailer had interviewed Jackie in 1960, during the campaign, and wrote of her "saucy regard," which is very evident in this photograph taken during the welcoming ceremony for President Prado of Peru and his wife in September 1961. Jackie wears a pink wool coat that was part of the Givenchy wardrobe for Paris.

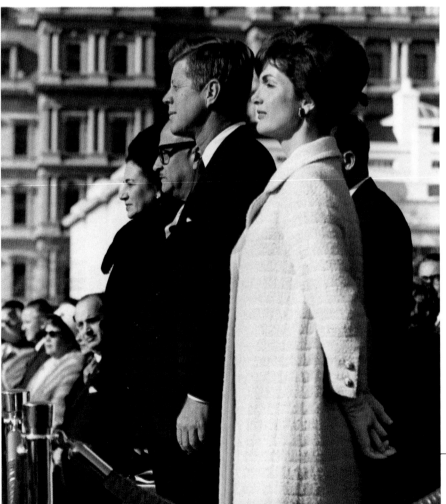

Standing at attention for the National Anthem, Jackie wears a white wool Chanel coat with gold buttons. She clasps her gloved hands together behind her back.

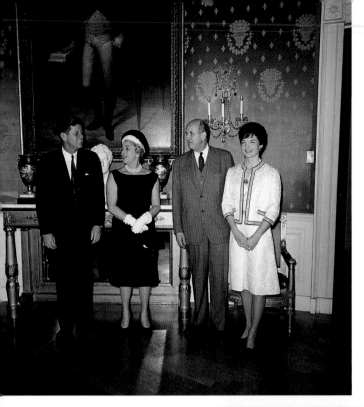

The American ambassador's secretary in Paris received an unusual request from the social office at the White House: "Mrs. Kennedy is ordering some Givenchy clothes—discreetly, we might say. When they are ready, which will be some time yet, would you be kind enough to get them at Givenchy's and deliver them into the hands of the Air Attaché for transmittal by air to us." The secretary recalled that "the couturiers in Paris would deliver boxes to me—Courrèges, Balmain, Givenchy. The boxes were never sealed. I used to open them up and show the clothes to the girls in the office. Then I'd seal them and give them to a Marine guard to deliver to the airport."

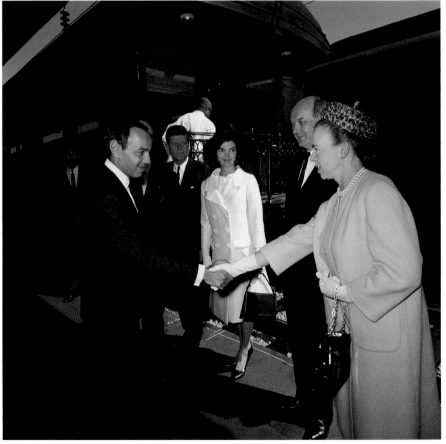

King Hassan II of Morocco greets Mrs. Dean Rusk, and the President and Mrs. Kennedy and the Secretary of State look on at Washington's Union Station. The First Lady's white coat and blouse are by Chanel. Jackie asked her clothing scout in Paris, Letizia Mowinckel, to get the crepe blouse that went with the coat.

Pictured with chief usher J. Bernard West on the day she was to move out of the White House, Jackie is dressed in the black wool suit she had worn throughout the funeral weekend. In July 1960 it was identified by *Women's Wear Daily* as a recent purchase by Mrs. Kennedy from Givenchy's fall 1959 collection.

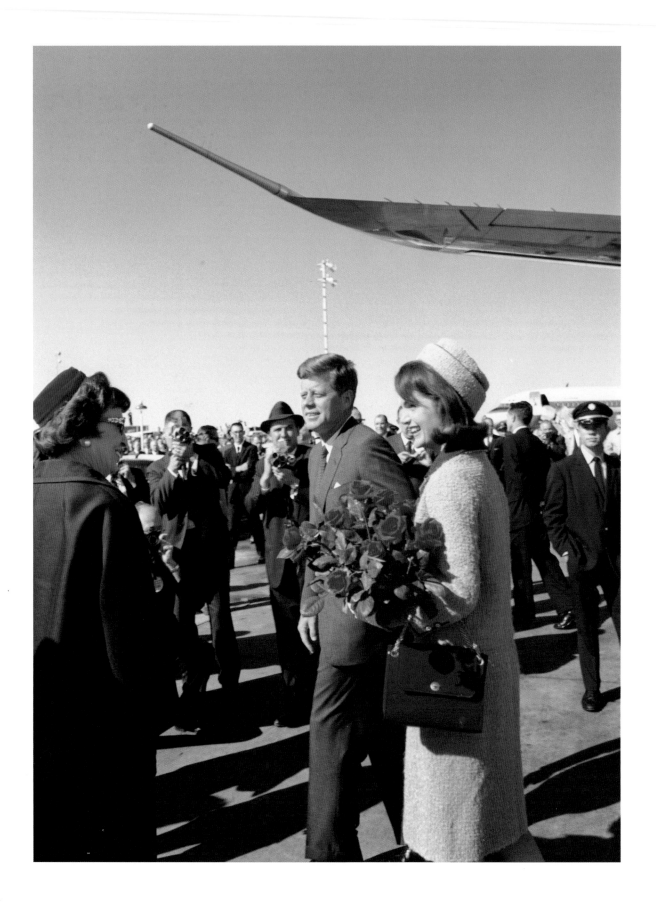

· chapter eight ·

November 1963

For the first time in their marriage he asked his wife what she intended to wear. Dallas especially interested him. "There are going to be all these rich Republican women at that lunch, wearing mink coats and diamond bracelets," he said, "and you've got to look as marvelous as any of them. Be simple—show these Texans what good taste really is." So she tramped in and out of his room, holding dresses in front of her. The outfits were finally chosen . . . all veterans of her wardrobe: beige and white dresses, blue and yellow suits, and, for Dallas, a pink suit with a navy blue collar and a matching pink pillbox hat.

—William Manchester,
The Death of a President

The month that ended in tragedy started in hope. Jacqueline Kennedy had spent the first three weeks of the previous month away from Washington. It was a recuperative trip, planned in the hope of raising the First Lady's spirits after the death of her son in August. Despite the potential political fallout, JFK insisted that the vacation go forward as planned. "I want her to go on this trip, it will be good for her," he told her press secretary, Pamela Turnure. Revolving around a two-week cruise of the Aegean aboard the yacht of Aristotle Onassis, the vacation included stops at several Greek isles and in Turkey, as well as a few days in Morocco as a guest of King Hassan II.

Jackie wrote her husband ten-page letters: "I miss you very much, I know I always exaggerate everything, but I realize here that I am having something you can never have—the absence of tension. I wish so much that I could give you that." When she returned on October 17, friends could see that there was renewed closeness, a new intimacy between the couple. So when her husband asked her to join him on a campaign trip toward the end of November, she opened her red-leather appointment book and scrawled, "Texas," across November 21, 22, and 23.

When Pamela Turnure was questioned about this trip—significant because it was the first trip west of Washington that the First Lady had made since the election—Jackie told her to "say I am going out with my husband on this trip and that it will be the first of many that I hope to make with him, and if they ask about campaigning, say yes, that I plan to campaign with him, and that I will do anything to help my husband be elected President again."

November started out quietly, with two weekends spent at Atoka. Jackie hadn't planned to resume her official White House duties until she returned from Texas, with a state dinner planned for West German Chancellor Ludwig Erhard. She felt relaxed enough to attend a performance of the Black Watch Pipers with JFK and their children and, the night before their departure, the annual judicial reception honoring the Supreme Court.

In preparing for Texas, Jackie was particularly sensitive to one aspect of the trip—her clothes. Pamela Turnure remembered that on "so many of the trips abroad the press was very interested in her wardrobe and who was in her entourage; when her hair was done. She was very much concerned about this trip not being played up this way, and that starting from her everything would be done to see that it was not. . . . She planned to buy no new things for this trip. . . . She would take a couple of suits she had had in her wardrobe for two years and one short dress for cocktails and a day dress and a coat, and the whole thing was very, very simple."

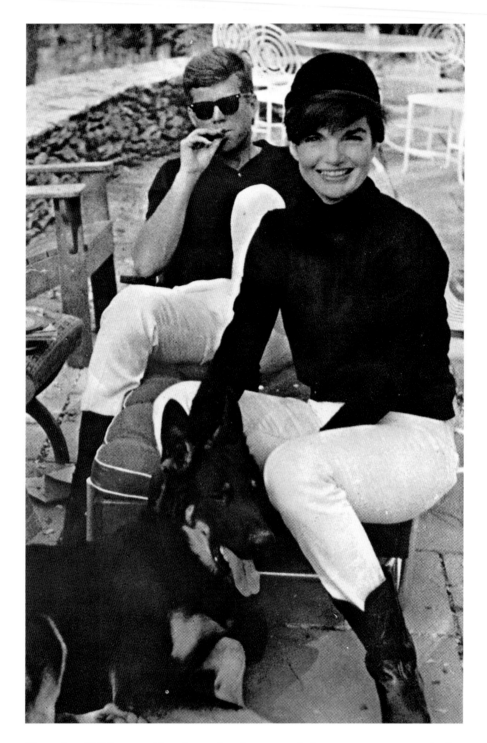

November 1963 began with quiet weekends spent at their new country estate, Atoka. The Kennedys had grown much closer after the death of their infant son that summer. As Jackie would later tell a friend, "It took a very long time for us to work everything out, but we did, and we were about to have a real life together."

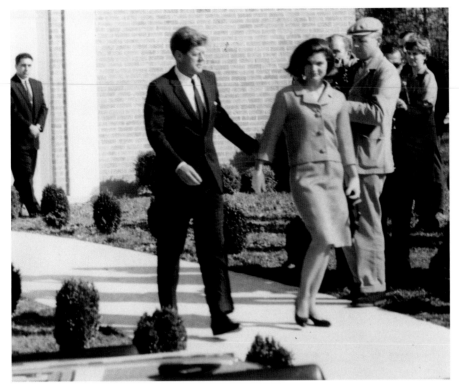

President and Mrs. Kennedy attended church together for the last time on Sunday, November 10, 1963, in Middleburg, Virginia.

Later that day they relaxed after lunch with their houseguests, including Ben and Tony Bradlee. JFK didn't much like their new house, spending only two full weekends there after it was completed. Jackie had asked White House chief usher J. Bernard West if any President had sold real estate while in office, and what he thought the ramifications might be. "You'd get twice what you paid for it" was his impish reply.

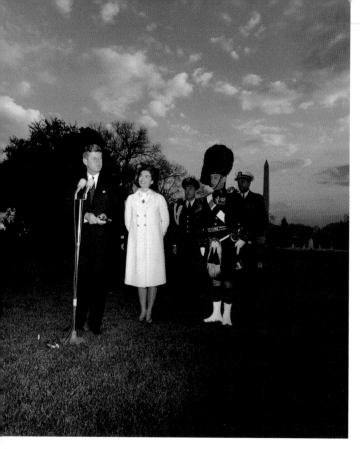

Britain's Royal Highland Regiment, the Black Watch, performed at the White House on November 13, 1963. Jackie watches happily as JFK addresses the seventeen hundred children in the audience. She later wrote: "I believe this ceremony was one of the most stirring we have ever had at the White House, and it was an afternoon which will be remembered for a long time. . . . I don't know when I have seen the President enjoy himself more." Twelve days later the pipers would return to Washington, at the special invitation of the widowed First Lady, to march in the funeral parade.

The judicial reception on November 20 was the last formal appearance of President and Mrs. John F. Kennedy in the White House. It hadn't been planned that way; Jackie had thought to rest in Virginia, saving her energy for the Texas trip. But a long conversation with JFK the evening before and an invigorating hour on horseback that morning had changed her mind. She returned to the Executive Mansion just in time to slip into a suit of cranberry velvet and join the Supreme Court justices and their wives. Ironically, many staffers had been invited to their first White House social event that evening. As the First Couple walked from room to room, they saw many familiar faces from the "New Frontier." For most of the guests, it was the last time they ever saw John F. Kennedy.

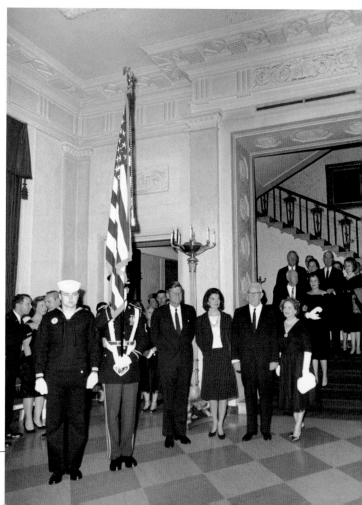

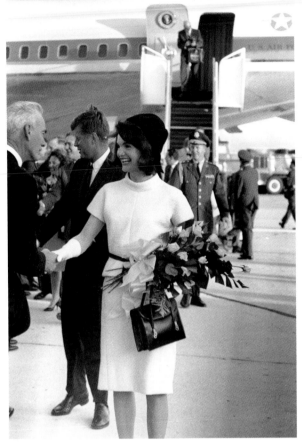

The first stop in Texas was San Antonio, and Jackie, lovely in a biscuit-colored two-piece wool dress with a slim black leather belt, enthusiastically went down the receiving line, shaking hands. JFK told a friend, "You have no idea what a help Jackie is to me, and what she has meant to me. *Didn't* she look beautiful?"

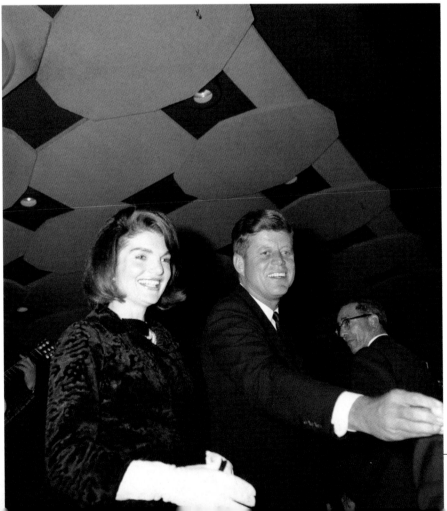

That evening, in Houston, the couple attended a reception for the League of United Latin-American Citizens (where she gave a short speech in Spanish) and a dinner in honor of Congressman Albert Thomas. Jackie wore a suit of black cut velvet, with a pearl necklace and earrings, her diamond bracelet, black satin shoes and evening bag, and her immaculate white gloves.

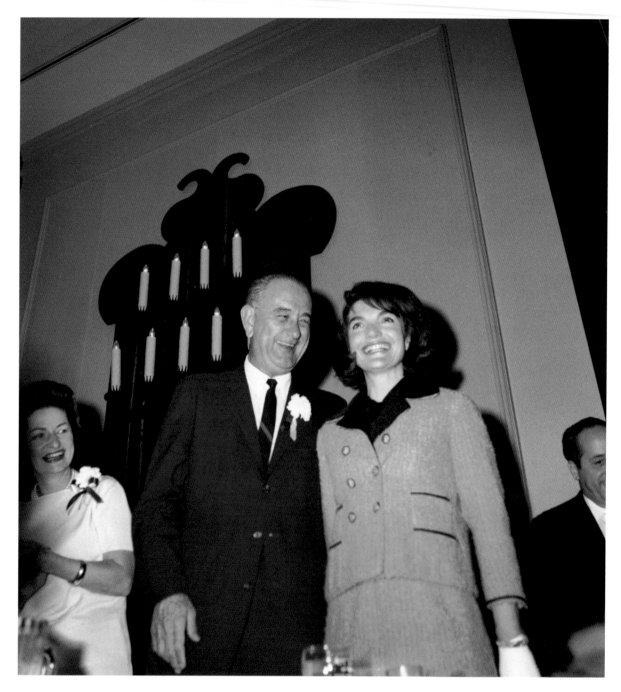

Jackie's first appearance the morning of November 22, 1963, was at a breakfast in Fort Worth, where she was greeted by Lyndon Johnson. The pink suit was indeed a veteran of her wardrobe. Two years old, it was a Chanel design, from the legendary couturier's fall 1961 collection. The pink wool jacket had six gold buttons, contrasting navy bands at the four pockets and on the three-quarter-length sleeves, and quilted navy silk revers. Ironically, a photograph of this suit appears in the same issue of *Life* magazine that featured the First Lady on the cover. Of the outfit, Jackie wrote to biographer Carl Anthony in 1987: "JFK picked out that suit."

She had worn the Chanel suit in October 1962, for a visit from the Maharaja and Maharani of Jaipur. Their visit coincided with the Cuban Missile Crisis, so instead of the dinner dance that had been planned, there was a private dinner for twelve guests, including the Duchess of Devonshire and Oleg Cassini.

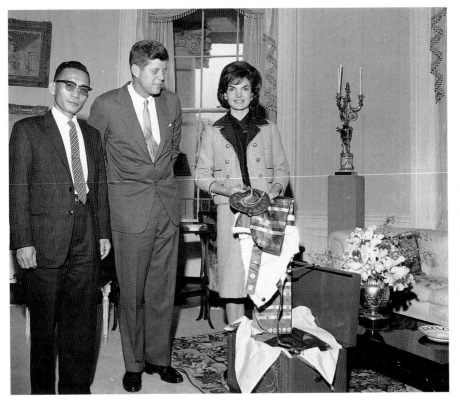

General Park Chung Hee of South Korea was entertained on November 14, 1961, at a stag luncheon. He exchanged gifts with the Kennedys (who frankly look a little dismayed at the stingy box of clothes) in the Yellow Oval Room in the family's private apartments.

One of Jacqueline Kennedy's real triumphs in her term as First Lady was saving Lafayette Square, the graceful surround of early-nineteenth-century houses off the north side of the White House. It had been slated for demolition, and at the last moment Jackie stepped in to convince District officials to rethink their plans. In 1962, with the help of architect John Carl Warnecke, a series of unobtrusive redbrick buildings were constructed behind the historic row houses. Here, on September 25, 1962, they review his plans.

On October 15, 1962, hiding with nurse Maud Shaw in the Rose Garden, Jackie holds John Kennedy Jr. aloft to watch the arrival of Algerian President Ben Bella.

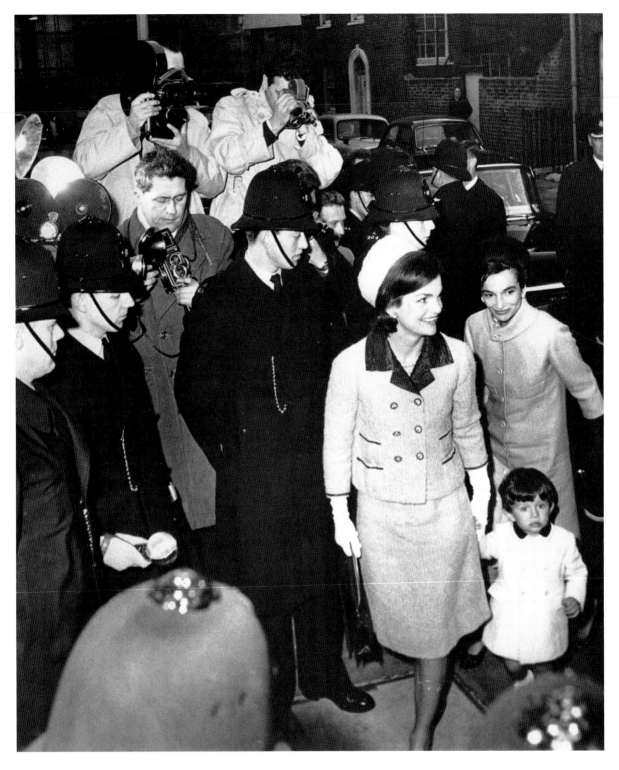

In London, en route home from India and Pakistan in March 1962, Jackie spent a few days visiting the Radziwells.

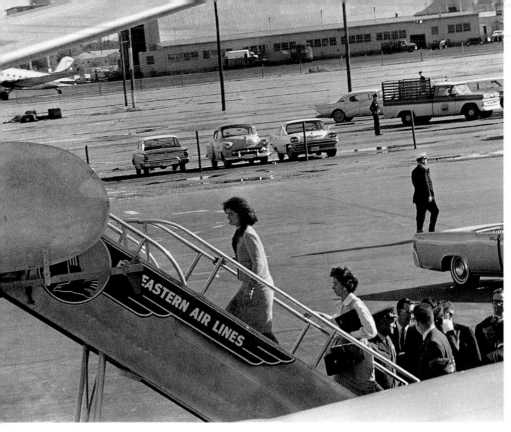

Left: Jacqueline Kennedy leaves Dallas, climbing aboard *Air Force One*, her suit and gloves stained with her husband's blood.

Below: An image ingrained in the souls of everyone who witnessed it: that Chanel suit has been engraved on our national psyche for almost forty years. A glimpse of the color, the nub of the fabric, and the box cut of the jacket instantaneously call to mind one of the defining events of twentieth-century American history.

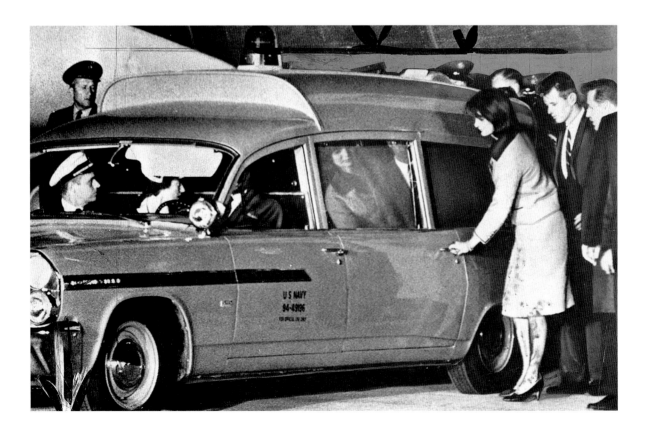

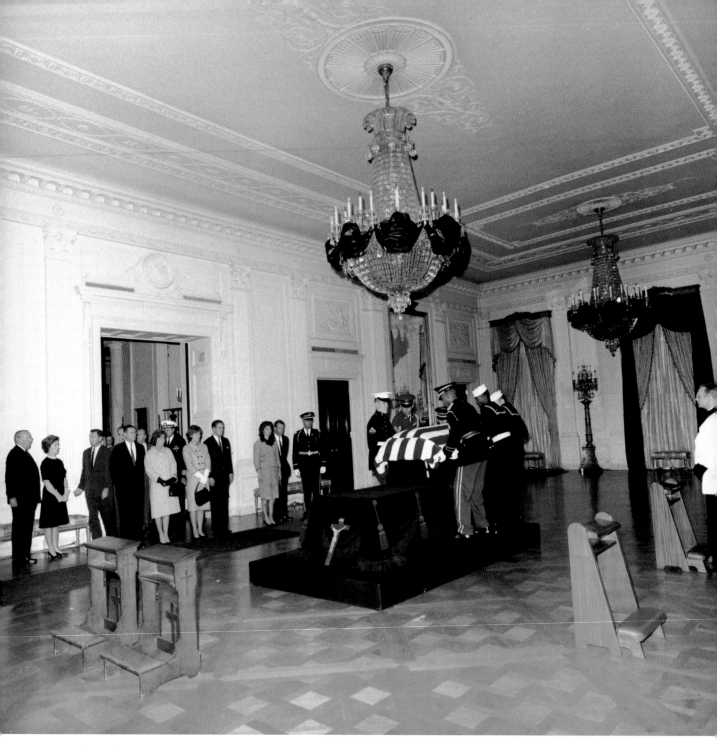

Early in the morning of Saturday, November 23, Jacqueline Kennedy returned to the White House. When Patrick had died that summer, JFK had told her, "We must not create an atmosphere of sadness in the White House because this would not be good for anyone, not for the country and not for the work we have to do." Her mother recalled that "this made a profound impression on her," and her behavior those four days—impeccable in every sense of the word—bears the stamp of both his feelings and her extraordinary strength of character.

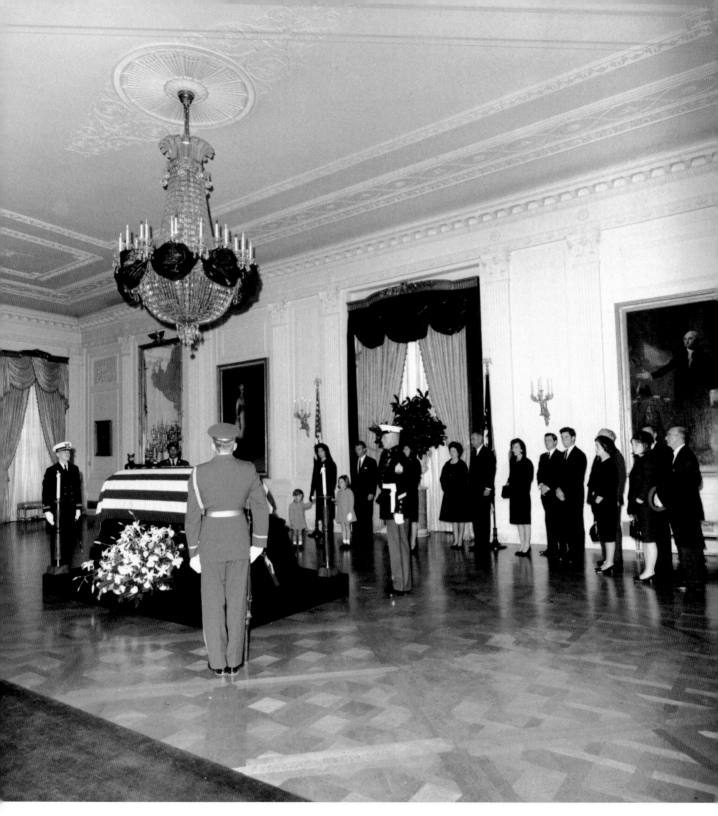

On Sunday, November 24, surrounded by her children and her Kennedy and Auchincloss relatives, Jacqueline Kennedy prepares to escort her husband's casket to the U.S. Capitol, where it will lie in state.

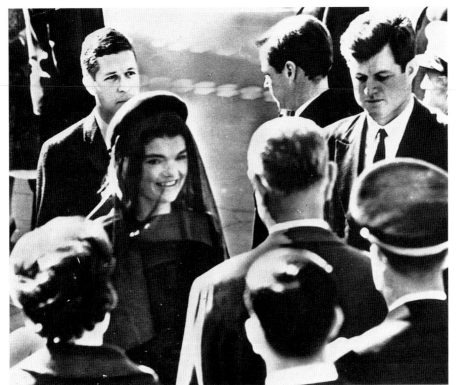

On Monday, November 25, the widowed First Lady offers a warm smile to President Johnson upon her arrival at St. Matthew's Cathedral. She wore her sister Lee's black beret and had asked her secretary to find "a long veil that's worn over the face." It was made for her by a White House seamstress.

Speaking of that horrible weekend, a friend paid Jackie this tribute: "Mrs. Kennedy carried through under the greatest amount of strain with more dignity that any woman in public life has ever shown in a moment of tragedy, and this was her last great tribute to him in her role." Here Jackie is escorted through the State Dining Room after the funeral.

Jackie speaks with the British Prime Minister, Sir Alec Douglas-Home, at a reception at the White House after the funeral. Tish Baldrige recalled, "This was a great show of strength on her part because she really should have been allowed to give in long before, and to have to suddenly be a hostess again. But it was her last time to be hostess and she wanted to do it well."

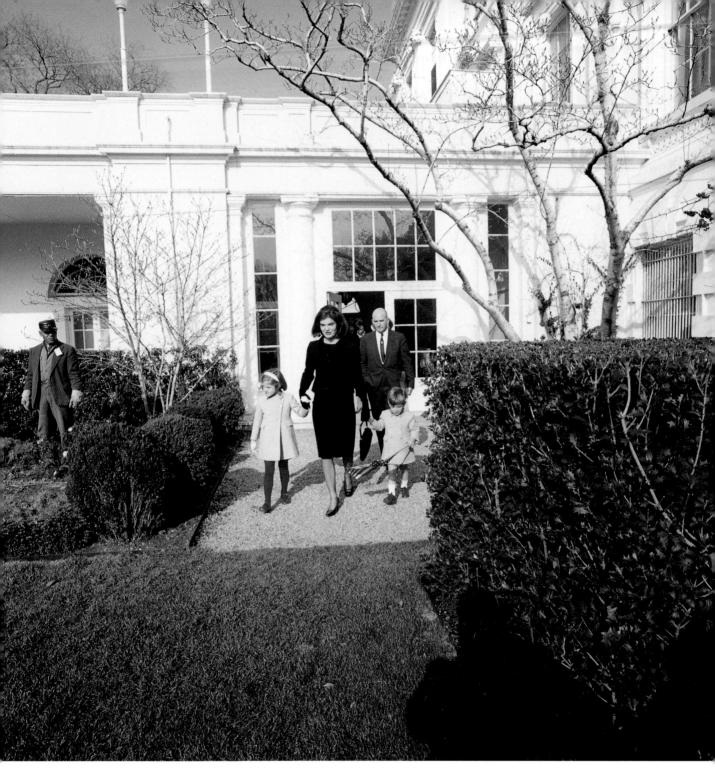

On December 6, 1963, Jacqueline Kennedy and her children moved out of the White House. She would return only a handful of times: to watch Caroline's Christmas pageant, to attend a ceremony honoring her Secret Service agent, and, for the last time, in 1971, to have dinner with President and Mrs. Richard Nixon and their two daughters prior to the unveiling of President Kennedy's and her official portraits.

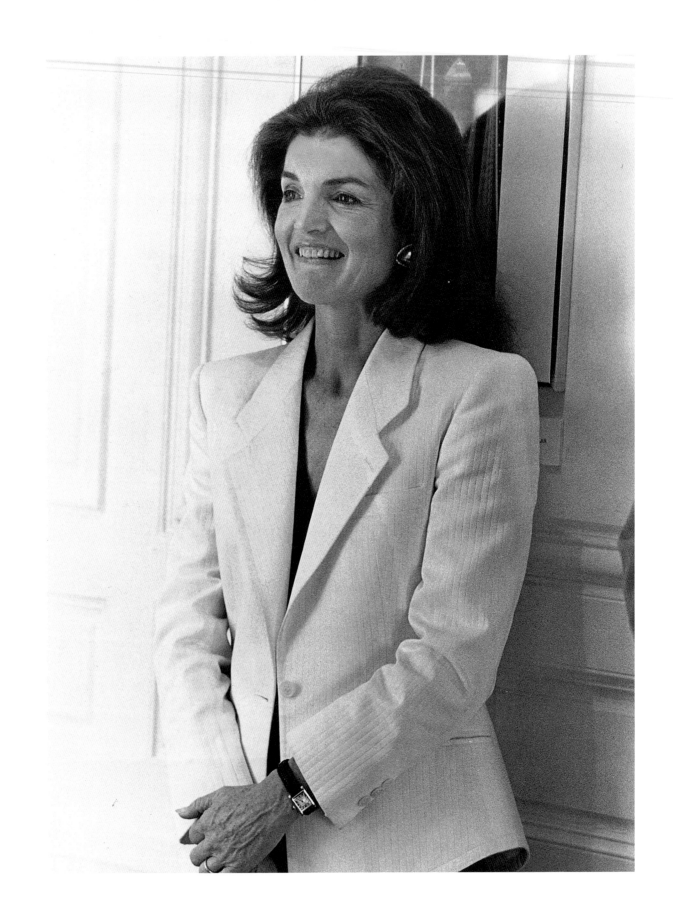

The Post-Camelot Years

In grand circles, the word class is considered a bad-taste word, but class is really the key word to describe her. Style, chic, and other such attributes are acquirable; class is not. Either you have it or you don't. Jackie had it in spades.

—Dominick Dunne

Jackie's post-Camelot life, in New York and Greece and Martha's Vineyard, saw a growth in her personal sense of style—always simple, always immaculate, but infused with a sense of freedom and fun that enhanced her looks as she gracefully eased her way into middle age. Her Camelot wardrobe, and its influence, can be seen in her mid-sixties clothes, and the Onassis years brought Halston and Valentino into her fashion vocabulary. But when she reached the last decade of her life, she had come full circle, from her mother's society dressmaker, Mini Rhea, to the quiet and elegant designs of Carolina Herrera. Mrs. Herrera made many of her clothes, including the lovely soft-green silk dress she wore to the wedding of her daughter, Caroline, to Ed Schlossberg in 1986.

Jackie's influence over fashion was a constant throughout her life—in ways both large and small. Browsing in Halston's Madison Avenue boutique one day in the 1970s, she noticed a young woman trying on a green cashmere sweater set and suggested, "You should take them, they go with your eyes." After the woman made the purchase, Jackie turned to Halston and mischievously purred, "Is that all it takes to sell clothes? Just a tiny suggestion?" Her relationship with Halston dated back to the late 1950s, when he worked in the custom millinery department at Bergdorf Goodman. He made many of the hats, including the famous inaugural pillbox that she wore throughout the early 1960s. There had been a controversy over who had "designed" the pillbox, an oval-shaped hat with a flat top and straight sides. Both Balenciaga and Dior had featured the hat in their collections, and Greta Garbo had worn one in the film *As You Desire Me* in 1932. When asked, Jackie credited Halston.

The *Philadelphia Enquirer* summed up Jacqueline Kennedy Onassis's impact on fashion in 1989 as follows: "For thirty years, she has been fashion dynamite, setting trends, breaking rules, and putting her stamp on American style."

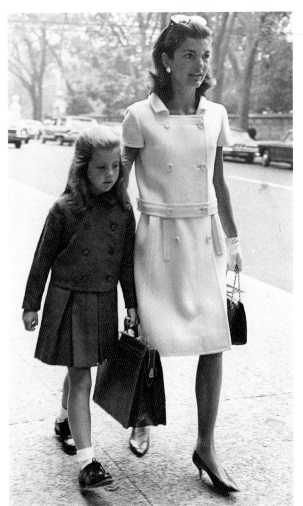

In the years following her move to New York City, Jackie, seen here walking Caroline to school in 1964, maintained her classic look—simple, crisp, clean. A white coatdress, low-heeled pumps, wrist-length gloves, and the ubiquitous sunglasses perched atop her head.

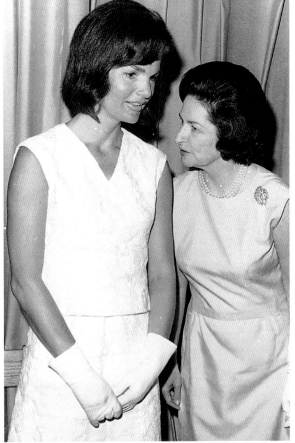

Jacqueline Kennedy became a private citizen in December 1963 and rarely made official appearances. One of the few was a reception for New York delegates at the 1964 Democratic Convention in Atlantic City. In a white silk brocade two-piece dress, sleeveless with a V-neck, she stood in a receiving line with Lady Bird Johnson.

In September 1965 Jackie returned to New York from Newport and was photographed in a white shift dress. White had long been accepted as a color worn in mourning by the royal families of Europe.

Her monochromatic look extended to sportswear. She's seen here on a ski trip to Stratton, Vermont.

When Pope Paul VI spoke at the United Nations in 1965, Jackie sat in rapt attention next to Richard Cardinal Cushing. She wore a black double-breasted suit with a velvet collar, and a large black bow in her hair.

When she came out of mourning, Jackie gave a party in New York and was seen wearing a slim white crepe gown with a sleeveless white mink vest.

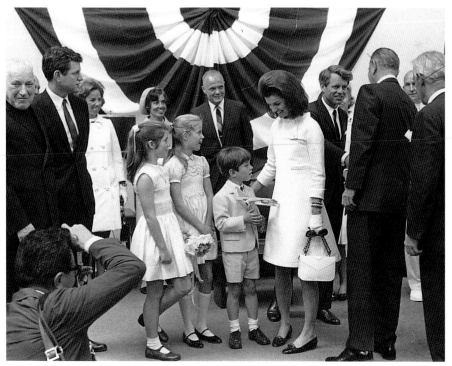

One of her last public duties was the launching of the U.S. Navy aircraft carrier named after her husband. Caroline, age nine, christened the ship while Jackie watched on in delight, wearing a white A-line coat, low-heeled pumps, and, as always, those gloves and that pair of dark sunglasses.

She looked terrific dressed down—in the classic preppy uniform of a Lacoste shirt and chinos—on a visit to Uxmal, Mexico.

Accompanied by her close friend Bunny Mellon, Jackie leaves her Fifth Avenue apartment en route to Kennedy Airport, where she would fly to Greece for her marriage to Aristotle Onassis. She wears a simply cut gray jersey minidress.

Jackie's dress for her second wedding was by Valentino, the Italian designer whom she gravitated toward in the late 1960s and for whom she was a faithful client for the rest of her life. He received dozens of orders for the dress after the Onassis wedding in October 1968.

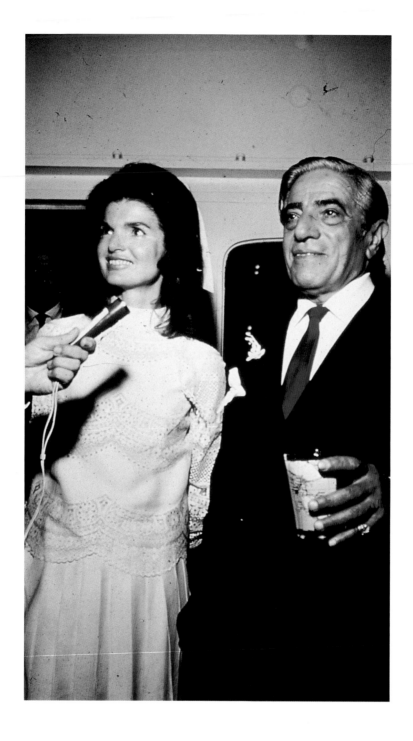

The Valentino dress was made of of ivory silk georgette and lace. It had a softly pleated skirt and a blouse decorated with bands of lace. She had worn the outfit the year before to the wedding of Bunny Mellon's daughter.

The year after her second wedding, Jackie attended a memorial service for Robert Kennedy at Arlington National Cemetery. JFK Jr. had yet to find the sartorial elegance that he would later embrace; like any eight-year-old boy, he wears clothes akimbo, but his tie is firmly anchored in place with a *PT-109* tie clasp. Jackie's black dress ends four inches above the knee. When she started wearing shorter skirts, *The New York Times* commented, "The future of the miniskirt is assured."

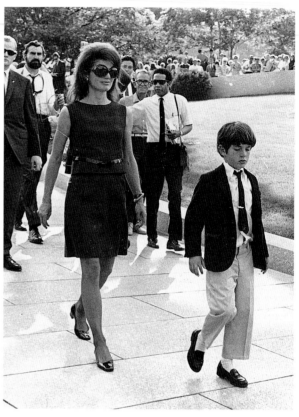

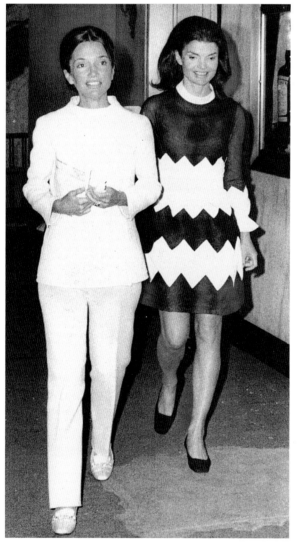

Jacqueline Onassis and her sister, Lee, attended the Stephen Sondheim musical *Company* in May 1970. It's easy to see why the two sisters were considered among the world's best-dressed women and that each had evolved a singular style, long removed from the days when they would be dressed identically.

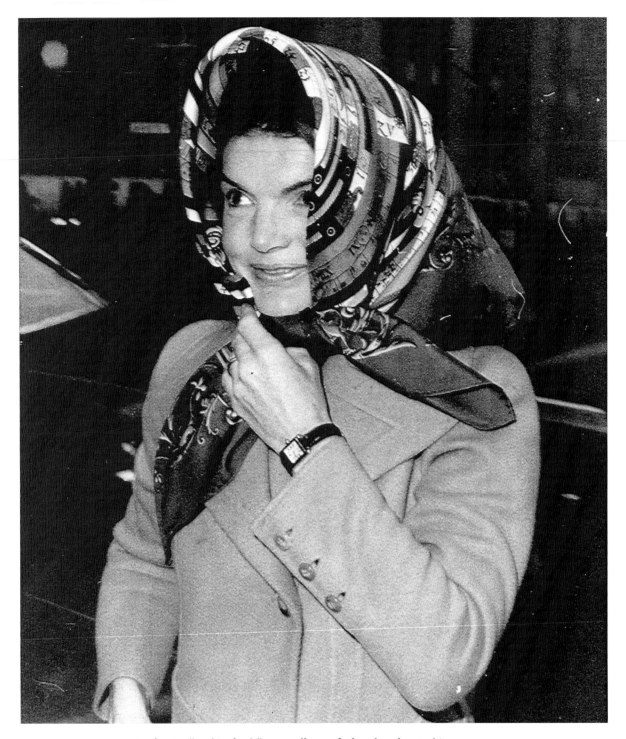

A classic "Jackie look" regardless of the decade. Jackie enters a
Manhattan courtroom to testify against photographer Ron Galella.
The scarf tied around her head, the simply tailored coat, and a Cartier
tank watch—timeless chic.

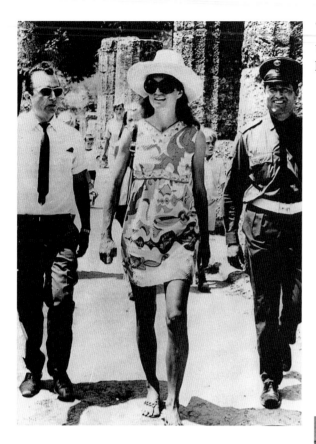

Touring the ruins of ancient Olympia in Greece, Jackie wears a brightly colored Pucci minidress, a wide-brimmed hat, and those great big sunglasses.

Jackie wears a fur-trimmed mini-length coat as she takes John and Caroline to Greece for the Christmas/New Year holidays. She carries a canvas and leather Hermès tote bag.

Her elegant choices in evening wear included this strapless gown by Madame Grès, worn to the opening of Diana Vreeland's *Vanity Fair* show at the Metropolitan Museum of Art in 1977.

"Jackie—the *Dynasty* Years." Big shoulders, big jewels, a powerful man at her side (CBS founder Bill Paley at this event), Jackie sailed through the 1980s in consummate style.

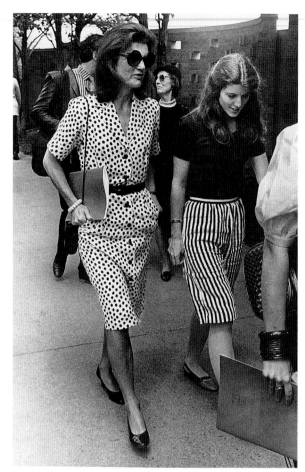

Jackie often chose clothes with a graphic simplicity that would stand out in photographs. Her black-and-white polka-dot dress is a chic modification of the classic shirtwaist.

Carolina Herrera designed the pale green silk dress that Jackie wore on one of the happiest days in her life, the day of the wedding of her daughter, Caroline, to Edwin Schlossberg in 1986. On the arm of her beloved brother-in-law Ted Kennedy, she watches, with pride and love obvious in her face, as the young couple leaves the church.

Women's Wear Daily gave her the nickname "Her Elegance" in the early 1960s. Thirty years later, it still applied. What could be simpler than a blouse, a pair of slacks, and a belt?

Jackie stands with Ted and her children at the JFK Library in Boston. The simple jacket, in her favorite pink with its distinctive square buttons, was a standard look for her later years.

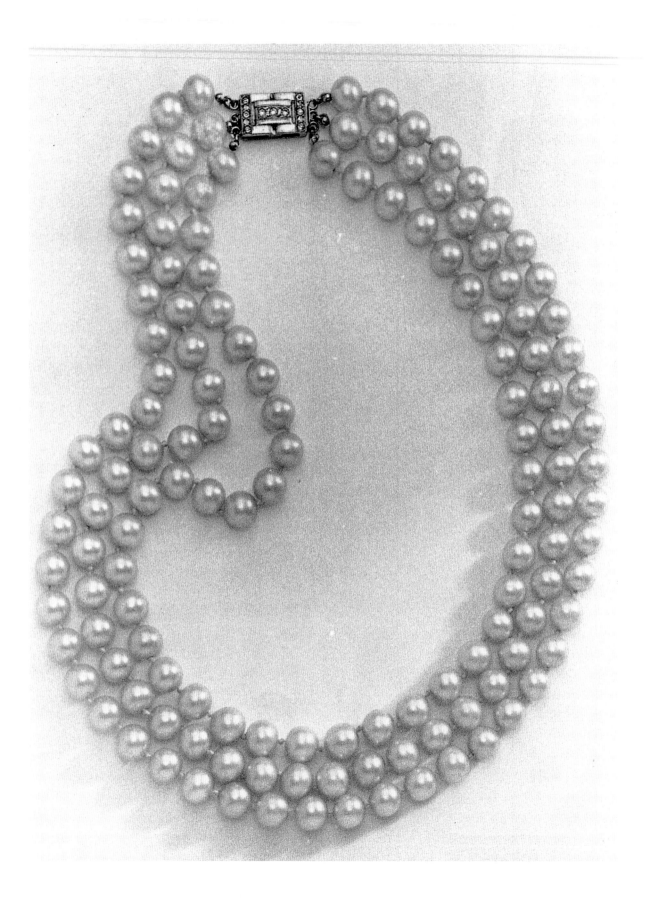

• chapter ten •

Jackie and Fashion

What difference could it make to anyone whether I wore two or three strings of pearls?

—Jacqueline Kennedy, 1962

To some people, apparently a great deal. When these pearls came up for auction in the legendary Sotheby's sale in 1996, we were surprised to learn that they were simulated (a fancy word for fake) and amazed to see the auction hammer come down at $211,500 for the necklace.

From the first mention of her fashion sense in *The New York Times* in August 1960 ("When Jacqueline Kennedy first stepped off a boat, five days the wife of the Democratic candidate for President, wearing bright pink Capri pants and an orange sweater, hardbitten reporters knew they were witnessing a revolution of sorts") to a major retrospective in one of the world's most renowned art institutions, Jackie's influence on fashion has never waned.

From the start, her clothes were copied and her style traveled around the globe. First Lady Betty Ford, a congressional wife in the 1960s, remembered the impact Jacqueline Kennedy had on fashion at the time: "All the women in Washington, all the women across the country copied her. . . . It was epidemic, that wardrobe."

Epidemic, perhaps, but not perfect. Jackie had her bad days, like every one of us. There were runs in her stockings and some spills on her blouses. She made some dubious choices and some outright mistakes, but they are few and can be forgiven, considering the four decades she moved under the unblinking eye of an ever-observing world.

She loved jewels and adornments, but always with restraint. First Lady Barbara Bush, known and loved for the triple strand of faux pearls worn throughout her White House tenure, freely admitted whom the idea was stolen from. When, in the 1980s, Jackie asked designer Kenneth Jay Lane to duplicate one of her fabulous Onassis-era necklaces of rubies, emeralds, and diamonds as costume jewelry, he agreed to assume the cost of making the model if he could sell the piece in his regular line. She agreed, and would telephone him in delight when she spotted the necklace on the scheming Alexis Carrington on TV's *Dynasty*.

Her influence hasn't stopped since her death. There was the Sotheby's auction, where her treasures went out into the world. There would be Jackie dolls with authentic Oleg Cassini wardrobes, and exact replicas of her famous triple strand of fake pearls (for those who couldn't afford the auction's stratospheric prices). The year after her death, the Paris collections were haunted by the ghost of Jacqueline Kennedy—dressmaker suits in muted tweeds with her favorite three-quarter-length sleeves sauntered down the runway at Chanel. She herself had referred to earlier revivals of her look as "silly," but there they were nonetheless. Her fashion influence remained as strong as her fame.

One aspect of Jacqueline Kennedy Onassis's character that rendered her unique in our celebrity-worshiping culture was this: her sense of self was absolutely disconnected from her fame. She was fully aware of it, of course, and for all the annoyance being "famous" cost her, she always managed to be polite and even sometimes playful with photographers and fans. She compared the unwanted attention to "a little cartoon that runs along at the bottom of your life—but one that doesn't have much to do with your life." Still, she was puzzled by the attention, remarking to a friend in 1991, "I'm sixty-two now, and I've been in the public eye for more than thirty years. I can't believe that anybody still cares about me or is still interested in what I do."

Mrs. John F. Kennedy

whose clothes reflect
her charm,
her spirit, and her natural
elegance;
for whom fashion is an attribute
of gracious
living

NATIONAL COAT AND SUIT INDUSTRY RECOVERY BOARD
February 1963

David Dubinsky
PRESIDENT ILGWU

Max S. Weinstein
CHAIRMAN

The First Lady's influence on the fashion industry was strong and very positive: sales of hats, gloves, belts, and sportswear boomed during her time in the White House. She was the first First Lady to influence two generations of American women simultaneously. Young women *and* their mothers strove to match Jackie's effortless chic. This citation, one of many awarded her during those years, was signed by David Dubinsky, a powerful labor leader and Democratic supporter.

Some Mishaps . . .

Do you remember that *Mary Tyler Moore Show* episode when everything went wrong for "perfect" Mary? When she got up to receive an award and moaned, "I usually don't look like this," in her ill-fitting borrowed dress, mottled hair, and fluffy bedroom slippers? Isn't it reassuring to know that Jackie could have a bad fashion day now and then? Those days are rare, but as Jane Austen writes of *Emma*, they help make Jackie "flawless in spite of her flaws."

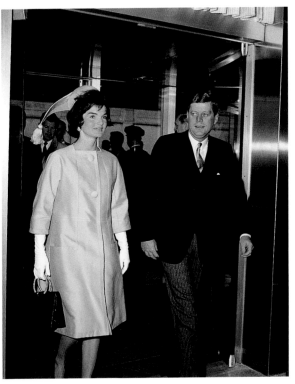

JFK looks askance at the rather silly hat that matches the matte gold silk coat Jackie wore to a ceremony at the Italian embassy. The hat, with its stocking-cap shape and tassel, looks like a costume for the commedia dell'arte. Perhaps that's what she had in mind?

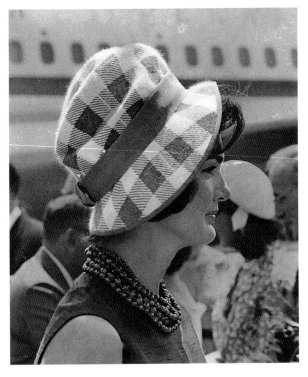

"Oh dear, it was so pleasant when I didn't have to wear hats. . . . I feel absurd in them," Jackie once said. We agree (just this once).

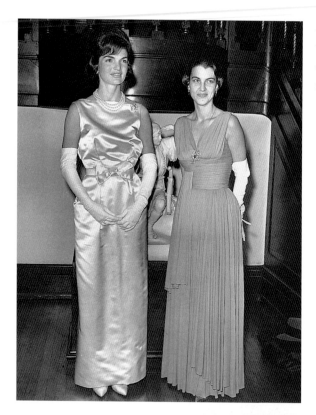

At a dinner at the Greek embassy, Madame Caramanlis, wife of the Prime Minister, looks lovely in softly pleated chiffon, but there seems to be something wrong with the fit of Jackie's white satin gown.

Jacqueline Kennedy gave a tea for alumnae of Miss Porter's School (she was a member of the class of '47), and somehow during the afternoon, something got spilled over the top of her dress. The silk and wool dress, in a muted pink check, was from Oleg Cassini's ready-to-wear collection.

"If we're not in Kansas anymore, then why am I wearing gingham?" seems to be the question Jackie is asking Pamela Harriman at a dinner in 1974.

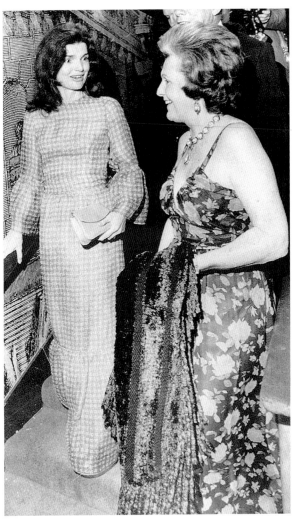

Jackie, no! Never, never wear shoulder pads with a sheer chiffon overblouse.

Voted "Best Coiffured Woman of 1962," the First Lady beat out such competition as her sister, Lee, Princess Grace, Doris Day, Mitzi Gaynor, Arlene Francis, and the star of TV's *Hazel*, Shirley Booth.

Jackie loved jewelry, and these were some of her favorite pieces. The pair of diamond wheat-sheaf pins, from Van Cleef & Arpels, were often worn in her hair or at her shoulders. The diamond-and-sapphire pin was often worn on a chain, and the matching earrings were worn frequently.

Jackie's most oft-worn jewel was this eighteenth-century diamond starburst pin, reproduced here by the Franklin Mint as part of its "Remembering Jackie" collection. She usually wore this pin as a tiara-like ornament in her hair, or on the bodice or waistline of an evening gown. She discovered the pin at Wartski's, the London jeweler, during her 1962 trip there and traded in several important pieces she owned (including the diamond pin Joseph P. Kennedy had given her as a wedding present and an aquamarine from the Brazilian government) in order to own it. She continued to wear this splendid pin throughout her life.

Alexandre, the world famous hairdresser whose clients ran the gamut from the Duchess of Windsor to Elizabeth Taylor, displays a sketch of the elaborate design he concocted for Jacqueline Kennedy's 1961 visit to Paris. She had sent him a lock of her hair in the international diplomatic pouch so he could create a hairpiece to augment her tresses.

Another rendering of the Jackie doll is this porcelain one featuring the white silk gazar gown worn in India. It includes real cultured pearls in the necklace and real sapphire earrings.

One sign of Jackie's enduring fashion legacy is this collection, issued by the Franklin Mint, of a Jacqueline Kennedy doll with a wardrobe of Oleg Cassini costumes. Each outfit is recreated from Cassini's original sketches and is precise down to the last detail.

Perhaps most treasured in the Franklin Mint collection is the porcelain wedding doll. Jackie's elaborate gown is copied down to the smallest detail, lovingly recreated. It's the first look that many people had of the woman who would become one of the most fabled of the century.

One Final Look

And now the journey is over,
too short, alas, too short.
It was filled with
adventure and wisdom
laughter and love
gallantry and grace.
So farewell, farewell.

—Maurice Tempelsman,
May 23, 1994

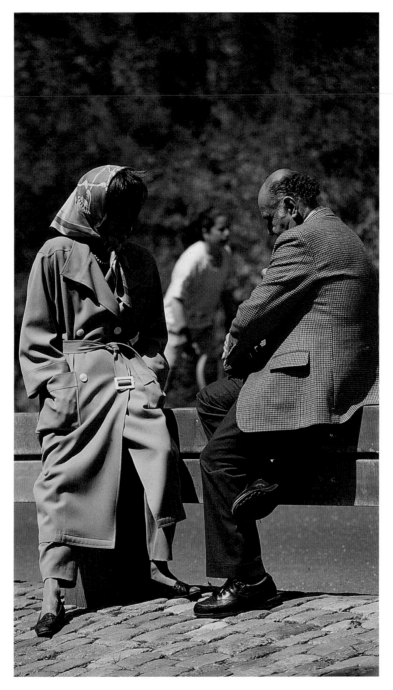

This was our last look at the woman who influenced so many parts of our lives in the last half of the twentieth century. Always true to herself and her style, Jackie rested in Central Park with her friend and companion Maurice Tempelsman in the spring of 1994. The scarf, the trench coat, the slacks, are, as always, immaculate, crisp, simple, and elegant—like the lady herself.

Photo Credits

AP/Worldwide Photos: endpapers(r), 17, 18, 19, 20, 22(t), 23, 25(t&b), 26(t&b), 27(t), 27(b), 60, 63(t), 69, 74, 75(t&b), 80(b), 96(b), 120, 121(t), 123, 125, 126, 127(t), 140, 157, 168, 171, 172, 174. *Boston Herald:* 21(t), 22(b), 24(t&b), 129(b), 137(b,l), 158(b), 169, 171, 175, 188. Corbis/Bettmann Archives: endpapers(l,b), XIII, 4, 6, 7, 27(m), 52, 58(t&b), 59(b), 60, 63(b), 64(t), 64(b), 66, 67, 74(b), 80(t), 89, 97(t), 125(t), 137(b,r), 141(t&b), 173, 186(t), 198. Courtesy of the Franklin Mint: 189(t,r), 190. JAM 3 Ltd.: 178(b), 180, 184. John F. Kennedy Library: endpapers(l,t), VIII, 5, 8, 9, 10, 11, 12, 16, 17, 18, 19, 21(b), 28, 32, 33, 34, 35, 36, 37, 38, 39, 40, 41, 42, 43, 44, 45, 46, 47, 48, 49, 50, 51, 56, 57, 59, 62, 68, 69, 70, 71, 72, 73, 76, 77, 78, 79, 81, 82, 83, 84, 88, 89, 90, 91, 92, 93, 94, 95, 96, 97, 98, 99, 100, 101, 102, 103, 104, 105, 106, 110, 111, 112, 113, 114, 115, 116, 117, 118, 119, 121, 122, 123, 124, 127, 128, 129, 130, 131, 132, 136, 137, 138, 139, 142, 143, 144, 145, 146, 151, 152, 153, 154, 155, 156, 158, 159, 160, 161, 162, 163, 185, 186, 189. Library of Congress: 20. Magnum Photos: 61, 62(t), 65, 150. Photofest: XII, 102, 122(t), 164, 168, 169, 172, 174, 179, 187.

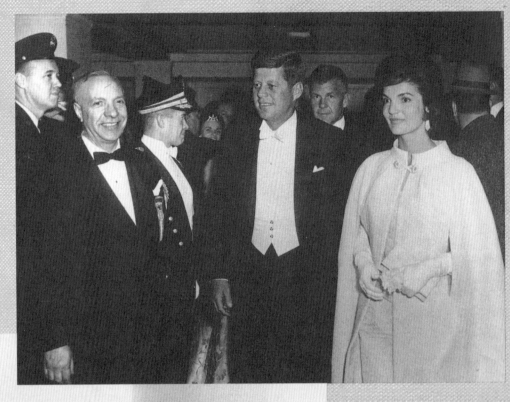

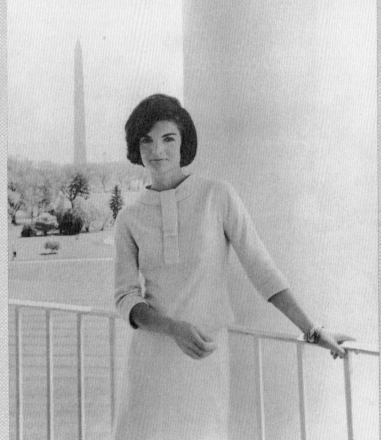